GILDED AGE

NORFOLK
VIRGINIA

GILDED AGE

NORFOLK
VIRGINIA

Tidewater Wealth, Industry and Propriety

JACLYN SPAINHOUR

THE
History
PRESS

Published by The History Press
Charleston, SC 29403
www.historypress.net

Copyright © 2015 by Jaclyn Spainhour
All rights reserved

Front cover images: *top left*: Hunter House, courtesy of the Hunter Foundation; *top right*: Hunter
children, courtesy of the Hunter Foundation; *bottom*: courtesy of the Sargeant Memorial
Room in the Norfolk Public Library.
Back cover images: *top*: advertisement for the Atlantic Hotel, courtesy of William Inge;
bottom: aerial view of Norfolk, courtesy of the Sargeant Memorial Room in the Norfolk
Public Library.

First published 2015

Manufactured in the United States

ISBN 978.1.46711.770.8

Library of Congress Control Number: 2015932379

This publication is dedicated to the docent staff of the Hunter House Victorian Museum, new and old, without whom the daily operations of the museum could not transpire. The board of directors, Margaret Spencer and I thank you for your service and commitment to the preservation and conservation of the museum and for recognizing its importance in our local history.

CONTENTS

Acknowledgements 9

1. Gilded Glamour: Social Life at the Turn of the Century 13
2. The Rise of Cosmopolitan Norfolk 35
3. A Home for Mr. Hunter: A Case Study of Décor and Decorum 63
4. Hired Hands: Life of the Day Servant 99
5. An Elegant Eternity: Elmwood Cemetery 103

Epilogue 107
Notes 111
Index 119
About the Author 123

ACKNOWLEDGEMENTS

*I*nspiration for this book came in many forms. I began volunteering at the Hunter House Victorian Museum as a docent almost five years ago and instantly fell in love with the history and romance of the house. Five years later, I find myself the assistant director. The creaking of the wood, the smell of old books and the eclectic décor had me from the beginning. The more I learned about the collection, though, the more I wanted to know about the family. Who were they? What were their daily lives like? What were their passions and fears? Unfortunately for me, the family did not leave materials to research these kinds of topics. I soon found myself at a crossroads—should I give up on finding more information on their personal lives, or should I make the most of what was available to me? I chose door number two.

In my quest to understand the Hunters, I learned I needed to understand the local community in which they lived during the late nineteenth century. As a result, what began as a project to re-create their home lives grew into a much larger project encompassing a short window of history that explores the daily lives and habits of the wealthy class residing in what is now considered the Downtown and Freemason Historic Districts in Norfolk. Within this much broader historical context, I have attempted to take the reader on a virtual tour of the home of the Hunters as it stood at the turn of the century. Much of what I discuss points to reasonable assumptions regarding experiences the Hunter family could have had as members of high society. I have tried to re-create their lives through what

ACKNOWLEDGEMENTS

they left behind: furniture, a few pictures, articles of clothing and their accompaniments and treasured collections resulting from their travels and elsewhere. Many of the conclusions I have made are probabilities rather than finite answers, but I have done my absolute best to provide the reader with the most factual interpretation of the museum possible. The Hunter House represents all that is beautiful about studying history, most of all that ideas are open for interpretation.

So, if you enjoy this book as much as I have enjoyed writing it, you must know that it would not have been possible without the encouragement and support of many other individuals. First and foremost, the staff at the museum has been indispensable. Margaret Spencer, the director of the museum, has tactfully answered all my probing questions with patience and ease and offered honest responses when there were holes in our information. The board of directors has trusted me to write a book that embodies the spirit of the family and the beauty of the house. Their faith in me continued to provide encouragement as I worked and reworked drafts of this manuscript. The staff at Norfolk Public Library's Sargeant Memorial Room, including William Inge and Troy Valos, has aided me greatly in my tedious research. Without their assistance, the creation of this book would still be a fantasy. I am indebted to my friend Cathy Smith, who lent her photography skills and provided many of the photos of the museum in this work. Longtime docent and my good friend Gloria Eatroff spent countless hours picking at my grammar and correcting my syntax without complaint, for which I am eternally grateful. Tim Bonney provided essential information and personal research for this project, for which there are no words to describe my gratitude. Without his dedication to the museum, many of these records would not be accessible today and could not have been used in this book. Dr. Anne-Taylor Cahill also provided encouragement and positive words to keep my spirits up. I am also exceedingly grateful to the docents who came before me and compiled information on the family and their collection. I have used many of these sources in this book.

I have been blessed to work with a wonderful publishing company that has welcomed my ideas and concerns from the beginning of the process. First and foremost, I want to thank my commissioning editor, Banks Smither, for all of his honesty and encouragement throughout my journey to publish this work. He has offered unparalleled guidance and has exhibited all the excitement I wished he would and more for the project. I would also like to express my gratitude to the editorial board for believing in my project and author platform, to my copyeditor for scrutinizing my work with a careful and kind eye and to my publicist for working tirelessly to make the success of

this work a reality. You have all made my publishing experience worthwhile and memorable.

On a more personal level, I would like to thank my family for their support throughout my education and career. To my dad, who always worried I had chosen an "unemployable major" when I picked history, thank you for seeing the joy it brings me and the calling I have to preserve our history and for sacrificing so much of your life to provide me with the opportunity to pursue my education. To my mom, thank you for being a pillar of patience with Dad and standing by me as I made those choices. To my grandma, or "Nanny" as I affectionately call her, I could not have done any of this without your guidance. You, like my mother, have believed in me from the very beginning. You always knew I would find my place in the world, and I hope you are proud of what I have accomplished. Thank you to the rest of my family members, who have supported me throughout the years as a student and in my career at the museum. Last, but certainly not least, I want to thank my wonderful husband, David. You are my rock in all that I do, and I could not have had the strength to finish this book without your unwavering love and belief in me.

Thank you to all who have aided in the production of this book, in whatever form that aid may have taken. Through your encouragement and assistance, the history of turn-of-the-century Norfolk and the Hunter House Victorian Museum will now be preserved for all.

Chapter 1

GILDED GLAMOUR

Social Life at the Turn of the Century

Most English dictionaries define the word "gilded" as a term synonymous with wealth or privilege. When applied to history, gilded takes on a very similar meaning, referring to a period in America's past when industry, innovation and prosperity were the markers of progress. Names like Carnegie, Rockefeller and Frick often grace the pages of American history textbooks exploring the impact of this period, yet very little historical importance is placed upon the seemingly average lives of everyday people. In towns and cities around the country, people from all walks of life experienced the late nineteenth century as it unveiled a newer, more advanced way of living. For the inhabitants of the seaport town of Norfolk, Virginia, their story is no different. Following a bout of yellow fever, the Civil War and its aftermath, Norfolk experienced the rise and fall of the industrial tides similarly to many other southern towns. Perhaps what makes its story unique is its locale in the heart of the birthplace of the nation itself, or even that Norfolk encompassed both a thriving metropolis and a stable rural economy alongside each other, working in tandem. Whichever the case, the Norfolkian experience during the Gilded Age deserves more exposure than it has been given. By peering behind the guise of nineteenth-century Norfolk's most prosperous families, seen today primarily in the many historical monuments, buildings and public spaces donated by and dedicated to these prominent groups, Norfolk's place as a prime example of a Gilded Age society is solidified on America's historical timeline.

Gilded Age Philanthropy

America's Gilded Age is an epoch that marks the end of the latter half of the Victorian era and thus exhibits many of the same social and economic characteristics of this overarching time period. The Victorian era is well noted for its attention to propriety and decorum, while the Gilded Age is saddled with the dichotomous adjectives of thrift and prosperity. When fused together in overlapping time periods, the success of combining innovation and wealth with frugality and modesty is made evident throughout the 1870s up to the turn of the century. Wealthy Norfolkian families embody these various ideals associated with the overlap of Victorian romanticism and Gilded Age innovation. Andrew Carnegie, an industry tycoon and philanthropist, personified the desires of many wealthy Americans to be remembered not for their wealth but for how they used it. In his 1889 essay "Wealth," commonly referred to as *The Gospel of Wealth*, Carnegie outlines the responsibility he believes the wealthy have to society.[1] In essence, he explains how to be a true philanthropist, sharing the fruits of one's financial successes with the local community and beyond. This sentiment spread furiously like a raging wildfire across the nation as affluent families began donating homes for the indigent, dedicating schools and purchasing land for churches and nonprofit organizations. In an unexpected financial upturn, the economic slump experienced by both the North and South during Reconstruction was replaced by prosperity and industry, spurred onward by this philanthropic craze of the wealthy.

In this respect, Norfolk's wealthiest families followed suit. Churches, schools, libraries and other buildings were financed by some of Norfolk's oldest family lineages. Such financiers and their contributions include Charles Allmand, whose home became a home for men; the Ballentine Home given by the family; the Lydia Roper Home given by her husband; the Mary Ludlow Home given by Countess Zollikofer; the land for the public library given by the Grandys and finances for the first branch library in Norfolk given by the Van Wycks; and the first park given by the Lesner family.[2] Today, many of the nineteenth-century homes of Norfolk's elite house small businesses, law firms, physicians' offices, historical societies and private residences. Many have also been torn down. During the 1960s, when historic preservation was not a priority for many cities, numerous homes were torn down and replaced with newer buildings rather than being conserved or repurposed. The few homes and public buildings that remain tell the stories and secrets of wealthy, privileged lifestyles lived within their walls.

Social Customs

An old adage states that along with great wealth comes great responsibility. For families of the Gilded Age, including those in Norfolk, this meant not only economic responsibility to aid the needy but also social responsibility to guide the morality and structure of each class in the communal hierarchy. In this respect, the wives and daughters of prominent men found their calling in life. These women can be categorized as trendsetters, popular and the like, but their classification as such was as much a burden as it was a blessing. They were held to the highest standards, and with that came specific obligations. First and foremost was to determine the social hierarchy in their local communities. Their weapon of choice was the infamous calling card. Calling cards determined a lady's social status, depending on how they were received and returned by the highest ranked ladies of leisure. If private calls were made in person and the fashionable ladies did not return in kind, the caller was made well aware of her social standing in the community. Of course, calling and other social customs were meant to be based on wealth and prestige, but with the rise in industry and overnight "new money" families, old southern belles often found themselves in a precarious position. With the system of "old money," it was a family's name and honor that guaranteed its rank in society; however, with the addition of newly wealthy families without a history of landownership and affluence, notable ladies in Norfolk and other southern areas watched helplessly as their social customs were subjected to scrutiny. The women of these newly wealthy families insisted they deserved to be placed within the ranks of these noblewomen, and many expected to be placed in the top tier among them. By using the calling cards and their special language, the "old money" ladies of the South could ensure these "new money" women knew their places. In most cases, upward social mobility would have to be earned, and at great expense to the often snubbed wives and daughters of industrial tycoons.

Victorian lifestyles were characterized by intrigue, whether it be abroad or at home. Men and women of the period managed to place importance on even the minutest detail of social decorum and were always quick to test one's breadth of knowledge of the rules of propriety. Afternoon tea often acted as a backdrop for these inquisitions, as did dinner parties and other social outings. The history of the establishments of afternoon tea as a meal mainstay is marked with rumor, which is surprisingly based in fact. The story suggests Queen Victoria was not satisfied with feeling famished in between her morning and evening meals and beckoned her servants to

send up some cakes and sandwiches with her tea to hold her over until her next meal. Over time, this policy was adopted by the aristocracy, who in turn were emulated to various degrees by the working-class and common folk. From there, the tradition of afternoon tea became a British cultural staple. When Americans began to adopt Victorian ideals around the mid-nineteenth century, afternoon tea was one aspect of British culture that was thoroughly embraced.

Social propriety could be measured by both social outings, like balls and dinners, and by one's involvement in charitable organizations. The wealthiest women founded homes for the indigent or schools for the blind, often with their husbands' money and without literal work or labor of any sort. The easiest method for women in Norfolk to check this box on their cultural résumé was to become involved in long-established charitable organizations, many with genealogical and religious ties. Among those with chapters in Norfolk were the Daughters of the American Revolution, Daughters of the Confederacy, the Huguenot Society and others. These institutions served a dichotomous purpose, first to solidify one's lineage and second to put that heritage to use within the community. Most historians today contend that the rise of these groups directly coincided with an influx in immigrants to many of the nation's growing cities. To combat these large immigrant populations and to perpetuate the myth of cultural supremacy of these founding families, Anglo-Americans developed genealogical organizations to preserve their ethnicity's legacy in society. Through these organizations, descendants of these prominent families became community builders as well as community nurturers. While men were busily at work within the walls of the various architectural triumphs of the city, many women were tying their family names to the virtues of charity and modesty. At once, men were the builders while women were the nurturers. There was never a time in Norfolk's history when involvement in this well-oiled machine was greater than during the Gilded Age.

Men and Norfolk's Virginia Club

Men often joined occupational societies or philanthropic brotherhoods to further their family honor and, hopefully, dominance within the community. The Ruritans, Freemasons, Shriners and the like all witnessed the rise of chapter membership in Norfolk during this period. The crème de la crème

of social belonging, though, came in the form of the infamous Virginia Club. According to George Holbert Tucker, "The Virginia Club…is Norfolk's oldest male coterie…its beginning…dates from June of 1873, when a party of bon vivants met 'by chance one evening' in the rooms of John Vermillion above Taylor's Drug Store at Bank and Freemason streets."[3] The club itself occupied many different structures throughout its existence, the first of which was at 59 Main Street.[1] A newer, more permanent location for the club was attained in 1888 at the corner of Plume and Granby Streets downtown. Due to a fire breaking out at the neighboring Atlantic Hotel in

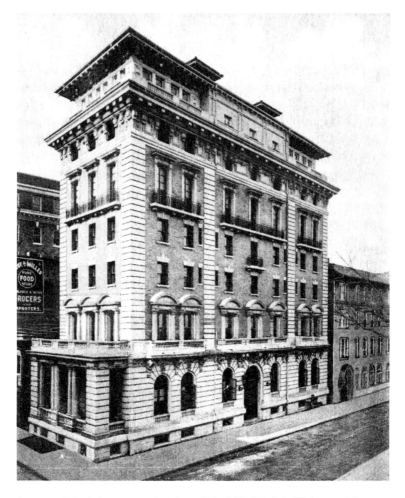

A postcard depicting an exterior view of Norfolk's Virginia Club, a social organization for prominent men. *Courtesy of William Inge.*

1902, the Virginia Club was forced to move to a temporary location at the corner of Granby and Freemason Streets. The club had been completely destroyed by the fire, and construction on a new location was complete in 1904. The club moved again in 1916 to West Freemason Street due to financial constraints and once more in 1919 to a home in the Ghent neighborhood, across the main road and outside downtown. In 1927, the club moved back into the Freemason district to the former M.T. Cooke Home located on 423 West Bute Street, where it remained for a mere one year, as the home was demolished in 1928. Afterward, the Virginia Club met at the Lorraine Hotel on Granby Street downtown. The club continued to prosper for many decades and still exists today. Some of its more notable members include men from the Whitehead, Taylor, Pinckney, Todd, Doyle, Rowland, Ward, Weston, Walke, Tucker, Hardy and Chamberlaine families, among others.[5]

The club was very exclusive and harbored an extensive set of rules for its members. Among these regulations were those concerning admission into the club, duties and the recreational activities available to members within the walls of the clubhouse. The bylaws of the Virginia Club state membership can only occur if a prospective member is elected by the governors of the ballot, proposed by one member and seconded by another. Additionally, only prime adult men are allowed admittance, as there is a regulation against anyone under the age of twenty-one.[6] All members were also required to pay monthly dues, which, if not paid in a timely manner, would result in termination of the person's membership.[7] Furthermore, behavior while on the club's premises was also highly regulated. Members were not allowed to give gratuity to the servants of the club, take away any materials from the club's library or visit after hours.[8] Rules concerning gaming were also quite interesting. Betting was not permitted, and neither was putting anything on credit in the game room. Article One, Section Two states: "All players of Cards shall, upon every day that they may play, deposit in a box kept for that purpose, the sum of ten cents. Billiards shall be paid for at the rate of ten cents per game. Cards will be furnished at cost price, with an addition of twenty-five per cent, and the price of Cards in all cases will invariably be cash."[9]

Moreover, other restrictions are placed on gaming in Article One, Sections Three and Four: "No game of any description shall be played on Sunday or Sunday nights…But two games of Billiards shall be played by gentlemen, when others are waiting to play. The observance of these rules is a point of honor."[10] Other rules concerning social propriety come from subsequent articles, such

as outlawing the presence of dogs in the clubhouse and ordering supper at an unreasonably late hour.[11] Also, members must not sleep or lie down on the couches in the club, nor should they smoke in the reading room. They also adopted a "you break it, you buy it" policy with the valuables held within the club's walls.[12] Despite its various restrictions, the Virginia Club has continued to welcome new members for over one hundred years, with its membership continuing to expand even today. Wealthy businessmen and other prominent lawyers, doctors and tradesmen were not truly of Norfolk's elite class until they secured membership in Norfolk's premier social group, the Virginia Club.

The Art of Travel

One of the defining aspects of the Gilded Age family was its desire to travel the world. Men, women and entire families readied their steamer trunks to travel both domestically and abroad, searching for the most exotic and intriguing pieces of culture that existed. Closer to home, many often ventured to visit with family and explore their towns of residence, while others abroad could dine on passenger ships or take carriages through the European countryside. Newlyweds of high society tended to honeymoon overseas on a European tour, which could last as long as six months. Without television or the Internet, the gateway to losing one's self in an era of rules and boundaries was through travel, and travel they did.

The methods of travel were the same, either by steamboat, carriage or car. Travel was often an uncomfortable business. Away from the luxuries of home, men and women carefully packed their belongings and headed out on journeys filled with rocky roads or swaying ocean vessels. Traveling became somewhat of an art, with each person collecting special carrying cases designed for specific items, like a grooming kit or a hat box. The rules of etiquette while traveling also changed, causing both men and women to prepare intensely for the physical and emotional toll of traveling. Books like Lillias Campbell Davidson's *Hints to Lady Travellers* provided insight into what one could expect to encounter while abroad and how to handle oneself during any and all situations. There is advice in this work ranging from how to hail a cab to which clothes to wear when mountain climbing. Nineteenth-century works like this one allowed travelers to obtain the rulebook they so desperately sought out.[13] For a society as structured as nineteenth-century America, a how-to guide was an ideal companion on any trip.

The journeys themselves and packing for them were stressful undertakings, and travelers often hoped the accommodations that would greet them upon arrival might spare them any further stress or injury. Some travelers were able to stay with relatives in their residences with all the comforts of home, while others looked to hotels for lodging. For the latter, better accommodations came with a hefty price tag. The nineteenth century witnessed the rise of some of the nation's grandest hotels, complete with bellmen, restaurants and individual rooms. This is markedly different from lodging in the eighteenth century. Prior to fancy hotels, tourists lodged in taverns, almost always sharing rooms with two or three other patrons. Privacy was a luxury that was only given to those traveling and staying by invitation with wealthy comrades.

In the nineteenth century, visitors to Norfolk could find comfortable accommodations in a variety of hotels downtown. Advertisements of the period abound with fanciful characterizations of the exquisite offerings of each hotel in Norfolk. As a result of the nearby Jamestown Exposition of 1907, Norfolk was receiving a flood of travelers, and many new hotels were built to accommodate their massive numbers. Competition for these guests rose significantly as these hotels were built, each advertising the best facets of its establishment. In a 1927 edition of the *Hotel Redbook and Directory*, nearly all hotels claim to be safe and fireproof.[11] Interestingly, the Atlantic Hotel offers neither of these adjectives to describe its establishment, most likely because the hotel had suffered a fire years earlier. The Monticello Hotel, located in the heart of downtown, offers the following advertisement:

> *Tidewater Virginia's Famous and Norfolk's Finest Hotel...European Plan...Fireproof...Covering entire city block and constructed along most improved lines. Spacious Halls and Corridors insuring an abundance of air and light and supplied throughout with the highest type of furniture and equipment. There are no finer Ballrooms, Convention Halls or Committee Rooms South of New York. The Monticello is famous for its cuisine.*[15]

Farther downtown, the Hotel Fairfax and the Atlantic Hotel attempted to draw in customers with similar advertisements. The Hotel Fairfax began by describing itself as

> *overlooking Norfolk Harbor in the Heart if the Business District... ABSOLUTELY FIREPROOF...within 20 miles of the best Ocean Beach in America, on concrete Highway. The Fairfax where the commercial traveler*

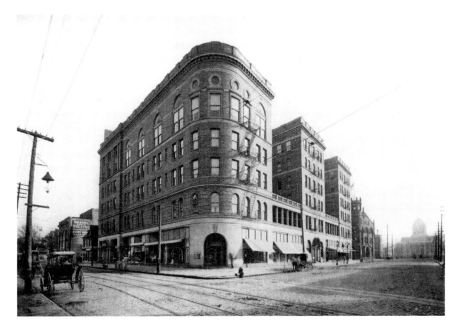

A photograph of the exterior of the Monticello Hotel. *Courtesy of Sargeant Memorial Collection, Norfolk Public Library.*

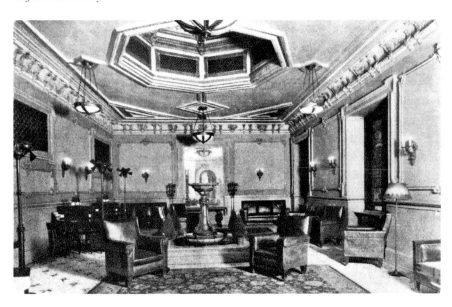

A postcard displaying the Fountain Room of the Atlantic Hotel, Norfolk. *Courtesy of William Inge.*

and motorist will find an atmosphere of friendship and personal care. Restaurants famous for excellent cuisine including Sea Food specialties at reasonable prices…beautiful rooms with tub and shower bath.[16]

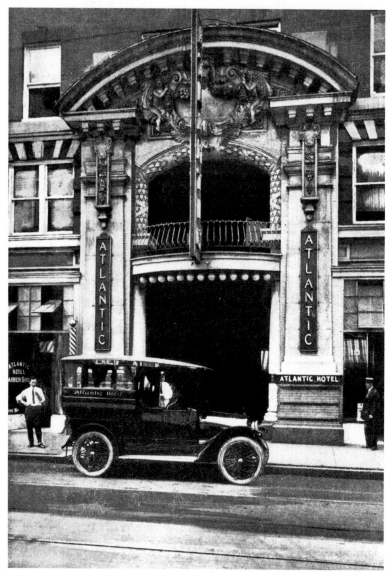

A postcard depicting the entrance to the Atlantic Hotel, Granby Street, Norfolk. *Courtesy of William Inge.*

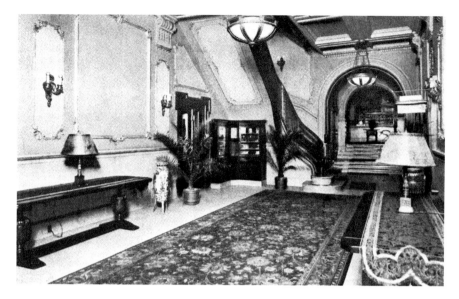

A postcard of the lobby of the Atlantic Hotel. *Courtesy of William Inge.*

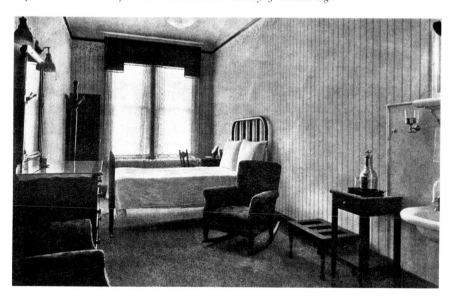

A postcard depicting "A Typical Bedroom" in the Atlantic Hotel. *Courtesy of William Inge.*

The Atlantic Hotel, with its tumultuous history, attempted to draw visitors in not with superfluous, embellished descriptions but with purely basic characterizations of its accommodations. It simply stated, "Located in the heart of the Business District. Free Shower Baths on Every Floor."[17]

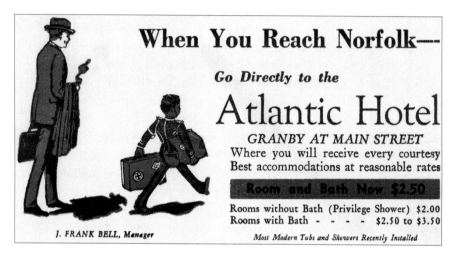

An advertisement for the room rates at the Atlantic Hotel depicting an African American bellboy. *Courtesy of William Inge.*

All hotels, with the exception of the Atlantic Hotel, unabashedly promoted fine dining rooms, private baths and convenience for businessmen and families alike. There were, of course, more than the three aforementioned hotels available to receive guests downtown. Among them were the New Victoria Hotel, the Lorraine, the Gladstone and others. Like so many others across the nation, each vigorously advertised in an attempt to stay afloat in a blooming, yet flooded, market.

Firsthand Travel Accounts

Many travelers wrote of their experiences across the Atlantic and abroad, especially women. As ladies of the period, it was acceptable for women to maintain correspondence with their families and friends. Traveling offered an excellent way for women to exercise their training in the art of penmanship. Female Victorian travelers, therefore, set out on a mission to explore foreign areas, hone their social skills or even gain a sense of autonomy. There are many examples of such travelers preserved today. Frances Elliot serves as a perfect example of a woman traveling during the Victorian era who gained a sense of self as a direct result of her travels. Elliot was married and divorced or separated twice, yet she lived a respectable existence as a middle-class citizen in Britain. She traveled all across Europe and the East,

and she wrote her own travel memoirs following her excursions. The most notable of her tourist trips are her well-documented travels to Italy, Spain and Constantinople.

Elliot appears to have enjoyed her trip to Spain the most and describes the company as excellent, save the incessant chatter she ascribed to Spanish women.[18] She states, "I find they are the most inveterate chatterboxes in the world, running over those terrible Arabic gutturals, and long j's with a glibness quite distracting."[19] In addition, she describes the typical Spanish woman as "distractingly pretty," which evidently, for her, was an unfortunate quality.[20] As a middle-class woman from the Victorian period, Elliot hones in on those qualities that set her apart from those she met on her travels. She complains of the language these women speak and their unfortunate beauty because these qualities are not in accordance with her own version of acceptable conduct. Elliot, like many other women of the Victorian era, did not find ostentatious behavior, sexualized appearance or forwardness in speech acceptable. Thus, she identified her culture as one that produces women who act as meek, submissive and plain-looking participants in society. While she is not very harsh with the Spaniards, she certainly goes to great lengths to describe the Spanish women in such a way that sets herself and her culture apart from them.

Elliot's harshest words are in her descriptions of Rome and its inhabitants. She states, "A dirtier, uglier, more ill-conditioned place than this once Papal city of refuge it would be hard to find. A squalid, insolent population lounge about the narrow streets."[21] She continues on this rampage, suggesting Rome is positively medieval in its customs, thereby asserting Britain's authority as a progressive and modern nation.[22] Her characterization of a landlady she meets in the streets is most intriguing. She states this woman was "fresh from her bed, wearing only a pair of stays and a thin petticoat, her hair as Nature pleases, her face smeared by contact with domestic utensils," yet she "evidently [was] a fine lady, however, spite of her drawbacks, and so accepted by the group."[23] Elliot implies a fine woman like her would never be permitted to act in such a manner, dressed improperly and lacking a clean appearance. This description of the landlady further solidifies what makes a woman Victorian: cleanliness, domestication and proper manners in the public sphere.

In her trip to Constantinople, Elliot reiterates much of the same feeling she expressed in her travels to Italy. She hones in most of all on the sexual nature of Ottoman women and the plainness of the landscape.[24] Her first impression of the destination begins with the assertion, "The crowd is so

vulgar, the surroundings so mean, I cannot abide it. It is a scene of low opera comique."[25] She then ventures toward Constantinople and passes a series of unfit graveyards, to which she remarks, "If, as it is said, a people is to be judged by the respect shown to the dead, Turkey is of all nations the most uncivilized."[26] She suggests if the Ottoman Turks had remained in their part of the world instead of meddling with Christians and moving farther west, then people (obviously a reference to herself and the culture of which she was a part) would not detest them as much.[27] Her attitude toward the Turks reflects the exclusivity of Victorian culture.

Elliot is not the only example of the many traveling Victorian women of the nineteenth century. Lady Elizabeth Craven is yet another prime example. She visited the Ottoman Empire and stated almost enviously that she had never seen a place where women had so much liberty and lived "free from all reproach."[28] Other widely recognized accounts of life abroad come from women like Mary Shelley and Lady Duff Gordon, each of whom had a different motive for travel. Mary Shelley was married with children. She traveled to Italy in the 1840s for pleasure, and her publications were widely read because of her popularity and notoriety.[29] Lady Duff Gordon, in contrast to Frances Elliot, was a member of the aristocracy. Unlike most traveling ladies, Lady Duff Gordon traveled for the sake of her health to Egypt in the 1860s.[30] Her journey offers an interesting location and an intriguing motivation for travel. These women provide interesting insight into the lives of those inhabitants of the places they visited, but the much more intriguing aspects of their writings are what their perceptions reveal about their own sense of Victorian identity.

In stark contrast to the unfavorable characterization of the Muslims Elliot provides, Lady Duff Gordon's description of Egypt and its inhabitants is quite pleasant. She remarks on the general congeniality of the people she meets, the social events she attends and the treatment she receives from both men and women.[31] She, unlike Elliot, does not seem interested in reinforcing the righteousness of Victorian social norms but in subtly challenging them. She includes a remark she claims was made by an unnamed group of Arabs that passes judgment on Englishmen. She states, "They are shocked at the way Englishmen talk about Hareem among themselves, and think the English hard and unkind to their wives and to women in general."[32] In addition to this assertion, she offers an extremely favorable compliment concerning the men in Egypt, stating, "Compared to the couriers and *laquais de place* of Europe, these men stand very high."[33] This is a vastly different characterization of the Turks,

whom Elliot described as uncivilized and vulgar. A comparison between Elliot and Lady Duff Gordon reveals not simply a difference in opinion but a possible difference in motivation as well. It is plausible Lady Duff Gordon offers such an amiable characterization of the society in Egypt because she either did not accept Victorian culture or she did not define her identity as Victorian in the same manner as Elliot. Frances Elliot is careful to place herself within the accepted constructs of femininity and Victorian identity, while Lady Duff Gordon expresses her opinions almost on a whim and without care. For Elliot, then, Victorian culture has strict boundaries that cannot be crossed, while Lady Duff Gordon's account suggests she possessed a more lenient definition for what it meant to be Victorian; either that, or she simply ignored the confines of her gender and culture and remained immersed in the society that surrounded her. More than likely, the first option is correct. Elliot and Lady Duff Gordon simply possessed differing ideas on both feminine behavior and Victorianism, as well as which behaviors were acceptable when traveling abroad.

Mary Shelley's work on Germany and Italy also proves interesting. What is most notable is her focus on geography and nature rather than people and customs. She describes the landscape and the natural elements of these areas, which both Elliot and Lady Duff Gordon touch on but do not linger on. Shelley admires Italy's "combination of beauty which [she] never saw equaled."[31] This focus on nature and the landscape indicates Shelley may have been like some of the other women previously mentioned who wished to provide accurate accounts to their readers to demonstrate their education levels. Shelley provides very detailed descriptions of sunsets, mountains, trees, shrubbery and other natural elements, almost as if she wants to transport the reader directly into her exact spot by providing the most detailed and scientifically and physically accurate portrayals of her surroundings. Perhaps she viewed this as a duty of hers, as a natural extension of the domestic sphere, as so many other Victorian women believed as well. Taking this interpretation into account, it appears Shelley and Elliot share similar ideas about Victorian identity and which behaviors are acceptable within the confines of their gender. Unlike Lady Duff Gordon, both Elliot and Shelley express their authority, autonomy and perceptions of others in a manner "suitable" for women of the Victorian era.

The Victorians and Spiritualism

On the other side of Victorian ideals of propriety was an intense fascination with the occult. The majority of the Victorian families mentioned in this book were of a Christian background, and a strict one at that. However, many of the families of the period, and possibly even some of those mentioned here, could have dabbled in the field of séances and spirit writing, though most likely as members of the audience rather than as esteemed performers. For those interested in the lives of these individuals, spiritualism as a whole continues to be one of the most intriguing and defining characteristics of Victorian identity. It appears to completely contradict the emotionless socializing that characterized the period, making it even more elusive. Unlike most of the other characteristics that defined the era, spiritualism was one of the rare topics that Americans created and was subsequently adopted by British high society, rather than the other way around. Through the hosting of séances, channeling of spirits and ghostwriting, the parlor became a gateway for Victorian women to entertain their neighbors while also achieving a sense of social freedom. Through the rise of spiritualism, ladies of the period were able to exercise authority previously denied to them during the long nineteenth century.

The parlor is often considered a feminine room, a place where ladies of the house could come together for calling, tea time and leisurely activities. Like so many parts of the Victorian home, the interior of the parlor was frequently designed and furnished at the discretion of the lady of the house. Lavish draperies, ornate furniture and beautifully designed wall coverings worked together to create a feminine space. Edith Wharton and Ogden Codman attest to the importance of interior decorating in creating the identity of a space in their work *The Decoration of Houses*. They state, "Each room in a house has its individual uses: some are made to sleep in, others are for dressing, eating, study, or conversation; but whatever the uses of a room, they are seriously interfered with if it be not preserved as a small room by itself."[35]

Wharton and Codman would contend that the ornamentation and decoration of the parlor is, in itself, an issue worthy of debate during the nineteenth century. The duo argues for a return to the older methods of adorning the parlor, free of happenstance furniture arrangements and unappealing bric-a-brac. The parlor, it seems, was under debate even before the séance was held within its walls. With the introduction of such entertainment, the parlor became a room of dualistic purpose: first as a place of formal gatherings and calling hours and second as a darker realm

for spiritual encounters. Scholar Marlene Tromp best characterizes this transformation, stating, "The darkened parlor of the séance invited and embodied the disruption of the ordinary."[36] Quite literally, it disrupted the "ordinary" gender divisions in Victorian society.

To understand this development, one must understand the rise of spiritualism. Victorian spiritualism began in an unlikely place: suburban New York. The infamous Kate and Margaret Fox experienced strange noises in their Hydesville home in 1848 and decided to investigate. Kate taunted the invisible noisemaker by directing questions to the entity, such as how old her brothers and sisters were, and asking it to repeat the sequences of her footsteps. When the entity did so, including giving the age of a deceased sibling, the family recognized the entity as an authentic otherworldly being. Kate and Margaret soon began conversing with the spirit and literally taking their show on the road, touring around the country claiming to be mediums for the spirit world. They became quite popular over the next few years but witnessed stagnation in interest by the mid-1850s.[37] Despite this lull, the girls continued their advances and solidified their place in the narrative of the rise of Victorian spiritualism.

Due to its decline in popularity in 1850s America, spiritualism and its proponents were forced to relocate to an area where they could maintain societal interest. Many of the American mediums who emerged after the success of the Fox sisters chose to leave their lives at home to pursue their own fame and prominence as mediums and ghostwriters. Luckily for these men and women, they found a much more sympathetic audience in the most popular destination: Britain. By the 1860s, spiritualism was a major staple in the British social diet, and it had returned to America in the subsequent decades.

Spiritualism was not completely received by all citizens, however. Staunch opposition emerged as spiritualism penetrated the realm and spiritualists increased both in number and popularity. Even the newspapers began to take stances for or against the phenomenon, printing stories related to the fallacies or authenticity of individual mediums, experiences of guests at séances and even critiques of the movement itself. The movement's rise in popular culture, regardless of stance, was so strong that it warranted the publication of various ghost stories in newspapers and periodicals as well.[38] Spiritualism literally infiltrated all areas of life for those both for and against the movement, its followers and its practitioners.

As the movement grew, it became clear that women were more frequently drawn to spiritualism, with the exception of the infamous Daniel Douglass Home. Home is arguably the most notorious medium in British history,

having offered séances for the British elite, royalty, practical naysayers and romantic loyalists.[39] As spiritualists came under attack by parts of their intended audience, deeming séances nothing other than illusion and trickery, Home published a work supporting the theory. In his *Lights and Shadows* of 1877, Home explains all the tricks of the trade used by false mediums, while continuing to assert he truly possessed the ability to communicate with spirits.[40] His seemingly contradictory action caused even further questions regarding his validity as a medium, but as it stands, no one was ever able to find evidence of trickery or fault in his abilities.[41]

Aside from Home and a handful of other spiritually gifted men, the majority of the spiritualism movement's followers and practitioners were decidedly women. Women could occupy two spaces within the movement: as mediums or other hands-on specialists who could make contact with the spirit world or as hostesses and attendees of séances. The former required much skill and a particular affinity for continuous attention, while the latter allowed many more women to participate within the hazy boundaries of the public and private spheres. It is vital to explore why women were perceived to be, and in actuality more likely to be, inclined toward spiritualism. Scholar Elana Gomel best explains this phenomenon, stating, "The Victorian doctrine of separate spheres was taken by Spiritualism to an uncanny, if logical, extreme: men belonged to this world, women to the next…women have a privileged access to the invisible world by virtue of being disenfranchised in the visible one."[42]

In essence, by being fated to live within the private sphere, Victorian women were actually in the best place to achieve liberation under the guise of spiritualism. Others would further suggest women were more susceptible to the spiritual world not just because they were cut off from public society but also because of the very attitudes that characterize the female gender. Victorians often classified women as intuitive, romantic and compassionate beings, making them very impressionable. The allure of spiritualism was no exception. As naturally sensitive beings, women were considered the most likely vehicle for contacting the spirit world. They were literally "sensitive" to interactions with ghostly beings. Furthermore, the combination of feminine sensitivity with a fundamental need to be socially acceptable allowed women to view the rise of spiritualism as an avenue for personal expression. A woman could choose to pursue the more feminine route of hosting and attending séances or transgress the gender boundary by being a medium or ghostwriter. Spiritualism was also infinitely more attractive to women of the period because it lacks a definitive hierarchy of power.[43] The lack of male

oversight within spiritualism put men and women, for once, on an equal playing field.

Women became managers of their homes, while their husbands became executives in the outside world. Everything within the home, from servants and linens to rooms and foodstuffs, fell under the authoritative jurisdiction of the watchful mistress of the house. By the turn of the century, women quite literally ran the Victorian home as an efficient domestic machine, making their own mark in the new age of industry.

As women took on roles within spiritualism, though, their authority within the parlor was often scrutinized. Women were certainly allowed, and altogether expected, to hold gatherings of friends, acquaintances and social superiors when possible. This was not a debated subject; however, when the purpose of the gathering took on a spiritualist connotation, the whispers of concern arose. Hostesses were criticized for allowing such poppycock into their homes when they invited mediums and ghostwriters to display their supposed talents for an elite group of viewers. By allowing these activities, they exercised so much autonomy in their parlors that they took on a seemingly masculine authority. Simply by hosting these séances, they invited scrutiny into their lives. The feminine parlor was perceived as being used as a meeting place for immoral behavior, as exhibited by the many critiques against these women and their séances. As séances became even more popular, the once safe and confining parlor became a wildling space viewed by many conservative Victorians to be the site of anti-religion. The parlor, essentially, was demonized in the same manner the female mind and body had been demonized for centuries.

While hostesses assuredly experienced steady criticism, nothing compared to the outright attacks that occurred on mediums and ghostwriters, moral and otherwise. Hostesses retained a majority of their expected femininity when hosting these gatherings, despite the criticisms toward the subject matter and their misuse of the parlor. It was the women who channeled spirits who truly were not behaving according to Victorian social standards. When claiming to channel a spirit, the woman acted as a vessel for the soul of the departed. By doing this, the woman could simultaneously be herself, a frail Victorian female, and the male spirit she channeled. Of course, there were female spirits as well, and they also caused quite a ruckus, but the majority of the issues regarding gender boundaries occurred when women channeled men, whether through direct contact and speech or ghostwriting. By claiming to speak for a man, the female medium was forced to step outside her accepted code of conduct and take on a male persona. This

could extend from the most simple of things, such as taking on the departed man's name, to the most uncharacteristic of women, for instance, discussing politics, religion and even financial situations. In a manner of speaking, these mediums lost the confines imposed on their sex when they assumed these masculine roles and acted accordingly. As a man, the female medium could indulge in many new behaviors and topics of conversation, supposedly without the ridicule she would experience if acting out those indulgences as a female. To her dismay, though, it soon became obvious that once the audience realized they were in fact listening to a woman speaking as a man, she was severely criticized. The audience's feeling toward the validity of the medium was irrelevant to this perception; the female medium was still a female no matter if she channeled a man or not.

When channeling a woman, though, the problem was often rooted in the mannerisms of the person channeled, not necessarily the topics of discussion. There are various depictions throughout British historical accounts, newspapers, books and periodicals that discuss the many inappropriate behaviors of the personas depicted by the typical female medium. Scholar Marlene Tromp describes such performances, suggesting, "Spirits flirtatiously engaged with their sitters, tendering kisses or the chance to squeeze their limbs or feel their hips as proof of their materiality."[11] Clearly, this type of mannerism would have produced quite the scandal in nineteenth-century Britain. In some ways, it turned the feminine parlor into a room of ill repute, as women allowed guests to touch their bare skin and flirted with reckless abandon. Perhaps what bothered the onlookers most was they seemed to witness the literal loss of innocence firsthand. One moment, a highbrow well-mannered young woman sat before them and urged them to take hands around the parlor table. The next, the same woman turned into a harlot, begging men to touch her in what was by Victorian standards very inappropriate ways. The reaction to this type of behavior seems to have been varied, although almost all participants were decidedly shocked. Women were almost embarrassed that a member of their own sex would act in such a way, while men were hesitant to indulge the medium in the behaviors asked of them, for they did not want to be perceived as morally incompetent as well. For the record, though, most men eventually indulged, although many explained they were respectable gentlemen and naturally uncomfortable with the situation.

Aside from mediums and hostesses, there were spiritual writers. These ghostwriters were a unique problem in Victorian society. As female mediums, all the aforementioned issues apply. However, the added element

for ghostwriters is that they do, in a manner of speaking, write for a public audience. Victorian women were certainly allowed and expected to write letters and maintain correspondence with family and friends as an extension of their feminine duties. To write publicly, though, was another issue entirely. Although a few women were publishing toward the end of the nineteenth century, most did so under pseudonyms or in conjunction with a male authority figure. This, in essence, prevented them from experiencing any real backlash. For female ghostwriters, or women who channeled spirits and simultaneously wrote down the words and images offered by the spirit during a séance, the lines of acceptability are difficult to ascertain. They were, after all, writing down thoughts and feelings for public display, even if it occurred in a private home and the writings assumedly came from the channeled spirit. It seems these women were not initially scrutinized severely for the writing aspect of their craft, although all the issues with being a female still applied. It was not until these women were deemed frauds that the veil was lifted regarding who authored the writings, and it was revealed these writings were the thoughts and feelings of the female medium. These women, then, transgressed the gender boundary even further than normal female mediums not practicing ghostwriting. They were the true deviants in the realm of female spiritualism.

It is important to take into account ideas like spiritualism, which are not often first thought of as defining characteristics of the Victorian identity. In Norfolk, throughout America and across the Atlantic, the phenomenon spread and aided in the development of true Victorian culture. Both men and women participated in various ways, but it is noted that women played the most direct roles in spiritualism. Men mainly served as bystanders, while women were much more likely to participate directly. The many women who experienced both autonomy and scrutiny as a result of spiritualism offer insight into a tiny yet vital aspect of this constructed persona of the Victorian. Female mediums and ghostwriters exercised control over their private parlor spaces and transformed them into dominions of spiritual authority by transgressing the accepted gender boundaries. At once female/ male, submissive/authoritative, calm/flamboyant and well-mannered/ vulgar, the female medium was in a unique position to experience all the behaviors associated with masculinity and femininity. She was an actress and real person all at once. For that reason, perhaps the Victorian female medium who constructed her persona in her workshop of a parlor pulled off the most enduring illusion of them all.

THE RISE OF COSMOPOLITAN NORFOLK

*I*n November 1890, a writer for the New York publication *Journal of Commerce* challenged his readers to find a more prosperous place than Virginia. He stated, "If any man knows of one gift with which nature has more richly endowed her than Virginia let him name it…Virginia is unsurpassed."[15] In actuality, this assertion was entirely correct. By 1900, Virginia had become a leading state in the production of raw goods, made major innovations in transportation and expanded its connections with the military. There were newer, improved railroad connections; expansions in maritime trade; and furthered connections to commercialism. There are few areas that compare to Norfolk in this respect. In the years following Reconstruction, Norfolk's population had expanded nearly 60 percent to forty thousand inhabitants.[16] The once small seaport town grew into a hub for railroads and industry.

Norfolk did not become a leading shipping port overnight. In fact, this city's road to prosperity began even before the nation itself was imagined. The founding of Norfolk is a story of apt leadership, highly desired location and communal expansion. The area began as all other early areas in Virginia did, as an effect of European exploration across the Atlantic Ocean. In 1607, nearby Jamestown was founded and recognized as the first permanent English settlement in North America. Years before, an attempt had been made to capitalize on the coast of what is now North Carolina at Roanoke Island. Most people remember the mysterious disappearance of the settlement in its entirety, with only a carving left behind on a tree to lead the inquisitive on an

irresolvable quest for answers. Dismissed as the remaining evidence of trouble with the natives, the fall of Roanoke Island was swept away as the English pressed onward to eventually create the Jamestown settlement. Uneducated in the ways of the New World and ill equipped to survive the disease-oriented landscape of the marshland, massive numbers of the settlers succumbed to malaria, dysentery and starvation. From the start, the initial settlement was doomed. The English ventured on this male-only voyage with the intention of striking gold in the New World, as well as obtaining the glory that came with beating the other European explorers to the punch. Their first major mistake was only sending males, a handicap that prohibited the expansion of the settlement until further waves of immigrants were sent for and arrived. Their second, and arguably much more harmful, mistake was the men chosen and sent on the mission. There were plenty of gentlemen, servants and other learned men among the brave explorers, but not one of them practiced any occupation necessary for survival. There were no farmers to speak of, an issue that forced interaction with the native population, often resulting in unpleasant experiences. In essence, the first settlers of the New World were privileged, not practical. These men suffered through a period of starvation, contaminated water and disease, but once women arrived and the initial onslaught ensued, the settlers eventually adapted to their bleak circumstances.

Eighteenth-Century Expansion and War

Over the next century, the settlement expanded to surrounding areas, including the part of the Tidewater region in which Norfolk is located. By October 1705, Norfolk was established as a town. Around this time, a very important Virginian, Colonel Byrd, is recorded as feeling optimistic about the future of his beloved Norfolk. He remarked, "The two cardinal virtues that make a place thrive—industry and frugality—are seen here in perfection; and so long as the people can banish luxury and idleness, the town will remain in a happy and flourishing condition."[17] By the end of the nineteenth century, it was apparent the town had done just that. This is not to say there were not various obstacles in the way of Norfolk's rise to prosperity. In fact, the record shows quite the contrary. By the time of the American Revolution, Norfolk, which had been designated as a borough for nearly forty years, found itself at the heart of the conflict. Due to its ideal location along the coast, Norfolk acted as a perfect location to block

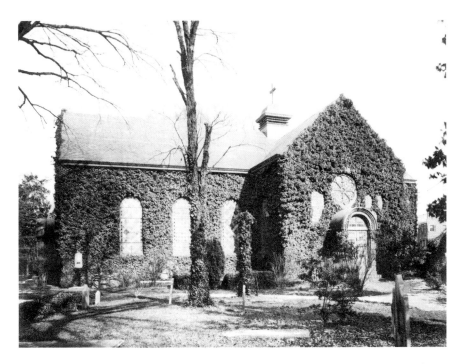

A photograph of the exterior of St. Paul's Episcopal Church. *Courtesy of Sargeant Memorial Collection, Norfolk Public Library.*

imported British goods and dispense messages as needed. It was during the Revolution that Norfolk witnessed its first major bought of destruction. "The Great Fire" raged throughout Norfolk on New Year's Day 1776, as Lord Dunmore ordered troops to burn the homes of Norfolk's prominent inhabitants to the ground.[48] Emma Blow Freeman Cook, a descendant of a combination of Norfolk's prestigious families, describes the scene as such:

> *We have seen the old cannon ball embedded in the wall of the old* [St. Paul's] *church, fired that fateful New Year's Day, when the Lord Dunmore bombarded the town. Knowing so well the habits of the pleasure-loving Borough people, he took advantage of the custom of observing New Year's Day in "at homes" and merry making, when each home was opened to callers unless illness or mourning necessitated the hanging of a basket on the knocker for receiving the cards of callers.*[49]

She goes on to explain how many families, upon hearing the cannonballs and shrieks of despair, fled the city. Some even chose to burn their own

homes rather than be disgraced by the British destroying their houses and social affluence. The homes lost were mainly in the chicest district of colonial Norfolk, containing the streets of "Fenchurch, Chapel, Holt, Church, and Bermuda."[50] In subsequent years, Norfolk and its founding families rebuilt their homes, and the city began to prosper.[51] By 1845, Norfolk was honored with the designation of city by a special act of the assembly.[52] Norfolk appeared to be on the rise in both wealth and population.

The Great Pestilence

In the summer of 1855, however, Norfolk was stricken with the worst plague in its history, the yellow fever. It is suggested the fever had been brought to Norfolk through local ports, specifically on an ocean steamship called the *Benjamin Franklin*. A workman on the ship contracted the fever and spread it to the Gosport Shipyard in Portsmouth, from which the disease carried and ravaged both Portsmouth and Norfolk.[53] Many fled the malady-stricken cities for country climates and mountain air, but those who stayed behind were in dire straits. Norfolk lost thousands of its citizens during the epidemic, many of which were not recorded, as it was not mandatory to do so at that time. This tragedy claimed the lives of many prominent doctors and holy men as they tended to the sick and dying. One of the most honored heroes of the epidemic is Reverend George D. Armstrong of the First Presbyterian Church of Norfolk. Armstrong and many of his religious contemporaries comforted the afflicted without hesitation or care for their own well-being. For this, many paid the ultimate price; however, Armstrong and a few others survived the fever, despite their proximity to the ill.[54] Reverend Armstrong is remembered even today within the walls of the church, which still stands on Norfolk's Colonial Avenue, albeit in an updated form.

Recollections of the Union Occupation

Within five years, Norfolk was subjected to yet another conflict, this time a civil war. The War of Northern Aggression, as it was affectionately called by most Southerners, began swiftly within the region. With the Confederate capital mere hours away from the city, Norfolk was in a dangerous position.

THE RISE OF COSMOPOLITAN NORFOLK

By May 1862, Northern forces had occupied the great seaport. Many accounts depict the struggle with Union forces, but none quite so eloquently as that of Camilla Frances Loyall of the Norfolk Loyalls. Camilla pens a diary covering the first few months of the occupation, prior to her death before the war reached its end. The sister-in-law of Union admiral David G. Farragut, she makes an interesting local case for the true embodiment of a "house divided."[55]

From May 1, 1862, to June 14, 1862, Camilla records events ranging from the most miniscule to vital developments in the war effort in Norfolk. She corroborates many of the historical events described by historians, such as General Burnside's visit to Norfolk, the opening of the port of Norfolk and the Battles of Fredericksburg and Seven Pines. Although at times historically inaccurate, Camilla Frances Loyall's diary provides vital insight into the effects of Union occupation on Confederate port cities, interracial relations and the roles of the women left to defend the "Lost Cause" at home, specifically in Norfolk.

Throughout her diary, three main motifs emerge: first, the presence of rumors in Norfolk's society regarding everything from slaves leaving their posts and entire families abandoning their homes to major victories for the Confederacy being published in the newspapers; second, the role of religion in combating the emotional and practical issues associated with being occupied by "the enemy"; and last, the tensing of racial relations. Camilla's diary illustrates how these strained relationships became a cornerstone for cultural unity in the Confederate South when all other social factors were lost during occupation. When all else had fallen to the Yankees, Camilla and her local Norfolk community continued to hold on to their hatred toward them for condemning their city to economic stagnation and, occasionally, death.

Camilla spends a great deal of time in her diary reiterating the "news" printed in newspapers, spread by locals or falsified by the Confederacy. There are many instances in which she inaccurately reports the Confederacy had won a battle it actually had lost and even, on one occasion, the war itself. This is not to suggest she is always mistaken in her accounts of events. She seems to have had access to very few avenues other than word of mouth, yet she correctly states details surrounding the Battle of Seven Pines and the attack on the Norfolk Naval Shipyard, among others. Occasionally, the newspapers she read might have given her accurate information, but many of these publications were certainly biased and constructed in a manner to boost morale for the cause. After all, newspapers that delivered the message that the Confederacy was most certainly at a disadvantage and probably fated to lose

the war would not have been accepted and certainly would not have turned a profit. As the days dragged on, Camilla and her female neighbors wasted away reading newspapers hoping for sections detailing accounts of their loved ones, only to be fed supposed truths and occasional bits of accurate information. This was not just an issue for the Norfolkians and the South, though. The North also had its share of biased newspapers that stated battles were won before they actually were or even suggested the war's end was near as early as 1862. Obviously, no matter from where one received the news, it was almost always laced with falsehoods.

Of all the rumors and news Camilla relays, the most interesting by far is her account of the initial occupation and the days that followed. On May 10, 1862, she states:

> *This day decides the fate of Norfolk. We are under the dominion of the Yankees. All of our troops got off today in the greatest state of excitement as the enemy landed quite early in the morning at Ocean View. The Indian Pole Bridge was burned down by our men to impede the progress. The Navy Yard was fired and the Dry Dock blown up under the charge of Capt. H. Page. The whole city in a panic, not knowing what to expect. Many are under the impression that the Court House and public buildings will be set on fire.*[56]

Luckily, her prediction that all the public buildings would be lost was not correct. However, Camilla's spirit appears to be breaking at this point. The following day, she continues her thoughts on the subject of the occupation:

> *Sunday morning, a melancholy Sabbath, not a church bell has been heard this day. The population too much depressed for general worship. The whole city alive with Yankees. Many are afraid to go in the streets; the harbor crowded with vessels of every description; the Union flag floats from all the public buildings; a day of deep humiliation to the whole city. We are entirely cut off from the Southern Confederacy.*[57]

This newfound feeling of pure isolation seems to have put Camilla in an even more dismal state of mind. She now began to comment more lengthily on the situation of slaves in Norfolk and its correlation with the loss of their dignity as a city. Up until this point, her discussion had focused primarily on the reactions of her own community to the impending encroachment by the Yankees. She remarks on people choosing to abandon their own homes and move out of the area for fear they and their belongings will come under

attack. She also points out how she witnessed entire communities escaping the area, as well as the difficulty in communicating with the world outside Norfolk through the postal system. Yet her attention on the many slaves who quite literally surrounded her in her life is few. The most illuminating thought, though, is written on May 11, 1862. Camilla says: "The excitement among the negroes is very great. They all think they are free and have already made many remarks that are very offensive, but we must expect it as the soldiers are already as familiar with them as if there was perfect equality."[58]

The situation between the races in Norfolk did not change for nearly one hundred years following this remark. Many of the slaves who were freed during this time found themselves in even worse predicaments following the war. They often turned to domestic labor as race relations stagnated and oftentimes declined. By the beginning of the Gilded Age in Norfolk, the relations between the races continued to be unpleasant.

By the end of the month, and halfway through her diary, Camilla has offered up prayers daily and often attempted to attend church services. On one occasion, she sadly states the prayer for President Jefferson Davis had to be omitted from service.[59] On another, she remarks on a conversation she had with her neighbor, Mr. Rodman. He told her he "commenced the services with the Litany, as he could not conscientiously, pray for the President of the United States, and he dare not pray for the President of the Confederacy."[60]

As her diary comes to a close, Camilla finds herself in a state of despair. Although trade has somewhat reopened and offices are beginning to operate, she cannot escape the personal shame she feels for her brother-in-law. It seems that no matter what she does, where she goes or who she speaks to, she is haunted by the ghost of his actions. For Camilla, the war had a profound personal effect on her life. She experienced the rush of rumors, comfort of religion and solidification of racial tension all under the guise of being the sister-in-law of a traitor to the Southern cause. Her diary offers very personal, revealing insight into life during the Union occupation of Norfolk, one of the most pivotal moments in the city's history.

Reconstruction and the End of the Nineteenth Century

Following the Civil War, like the rest of the South, Virginia entered into a state of Reconstruction. As difficult as this period was for the affluent families of Norfolk, it was much worse for those who served them. African

American families, freed from the chains of slavery, now found themselves servants to the unholy dollar. Families throughout the South were unwilling to pay for services previously performed for free, and many freed slaves and their families suffered as a result. Over the next twenty years, these families reintegrated into society as housekeepers and gardeners and in other forms of servitude. For Norfolk's prominent households, life was looking optimistic. By the 1890s, Norfolk had recovered from the angst and poverty that characterized the Civil War and its aftermath. The last decade of the nineteenth century became a golden age of sorts, expanding the social life, level of innovation and rise of economic prosperity of Norfolk.[61]

It is within this framework of industrialization that James Wilson Hunter decided to build his family home in the up-and-coming area of downtown Norfolk. He had a history with Norfolk itself, starting his humble beginnings as a "wholesale dry goods and notions" clerk downtown.[62] The business was located at 42 and 44 Commerce Street and was popularly known as Corprew & Hunter, later called J.W. & Co. Dry Goods and Notions, a wholesale company. By 1894, Hunter had become profitable in retail but found even greater opportunity when he began to pursue a career in banking. According to the chamber of commerce reports from 1890, just a few years before Hunter stepped into the realm of banking, banking houses were on the rise in the area. Ten such houses, including two

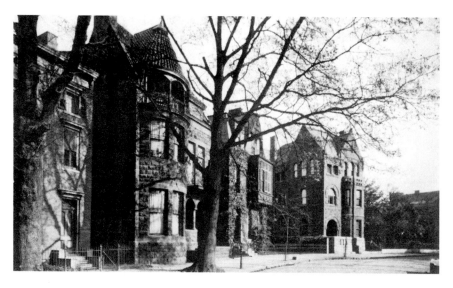

A view down Freemason Street, including the Hunter House on the far right. *Courtesy of Sargeant Memorial Collection, Norfolk Public Library.*

privately owned firms, were present in Norfolk alone. Hunter joined the Bank of Commerce as its chief financial officer, a business then ranked as the third most profitable banking house in Norfolk.[63] From 1903 to 1923, Hunter floated between various banking houses, collecting his earnings as he went. He is recorded as serving as president of the Virginia Bank and Trust Company, which changed names many times while he was there, until 1921. By 1920, he had become chairman of the board of the Virginia National Bank and the Virginia Bank and Trust Company. He experienced a long and prosperous career in banking. His blossoming career coincided directly with the construction of the Hunter family home. As the economic sector began to expand in Norfolk, so did Hunter's personal wealth. By 1894, he had commissioned Bostonian architect William Pitt Wentworth to build his family a new home in the heart of the city, close to his prospering career and away from the more rural Princess Anne County in which he had lived as a young man. Within a mere year, the home was complete, and the Hunter family began their legacy as a prominent local family forever embedded in Norfolk's history.

Downtown Buildings and Residences

The world in which the Hunters and other prominent Norfolkian families resided was lined with fabulous hotels, exquisitely crafted public and private buildings, family-run businesses and places of leisure. By the 1890s, there was a new pumping station for the water supply, a paid firefighting force and horse-drawn streetcars running through the downtown streets. In 1894, the city was electrified and electric trolleys were implemented, although bicycles continued to be a valuable method of travel.[64] Many of the faces that greeted these city dwellers were of "painted ladies," a term of endearment used to describe the beautiful homes of the nineteenth-century nouveau riche. Some were found in the heart of historic downtown, where the most thriving businesses were located, while others were built at the edge of the expanding city. Freemason Street, where the Hunters resided, was among one of many new streets that served as the locations of family homes for wealthy urbanites. The greatest homes were being constructed in the highest-priced areas, namely in lots on Duke, York, Bute, Granby, Freemason and Boush.[65] Between 1883 and 1887, prices for lots in this area rose between 30 and 50 percent, with Freemason and Bute Streets being the most highly desired,

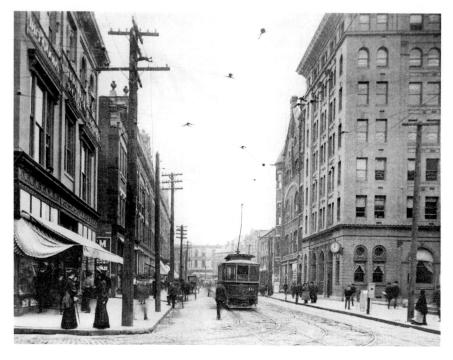

Looking east on Main Street at the intersection of Granby Street with electric trolley cars. *Courtesy of Sargeant Memorial Collection, Norfolk Public Library.*

Opposite, bottom: A postcard depicting Norfolk's Boush Street at the turn of the century. *Courtesy of William Inge.*

as reflected in their prices.[66] By 1895, the downtown area had expanded to include many of these affluent residences, often housing learned men of the working class, primarily doctors and lawyers.[67] There are far too many historically important families who grace the pages of Norfolk's history to be examined in detail in this work, but many of them are mentioned consistently in recollections of the period. Some of these families include the descendants of the households of "Page, Dancy, Dobie, Selden, Tunstall, Whittle, Walke, Whitehead, Grandy, Myers, Blow" and others who regularly held "at home" hours as members of the leisurely class and were well known within the community.[68]

The Freemason District contained the homes of the many aforementioned families and their descendants. In the 300 block of Freemason Street resided the Westons, Grandys and Ropers, among others. The majority of these families were of new money, as they profited from developments

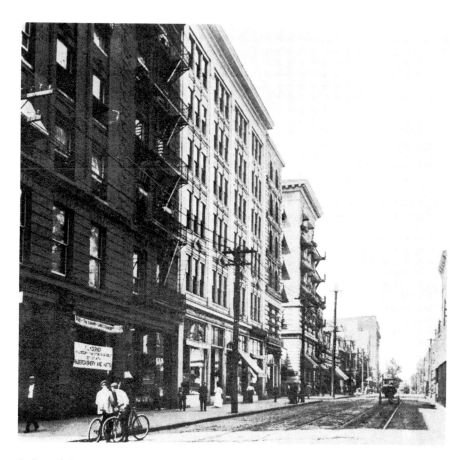

A view of Granby Street near Tazewell Street. *Courtesy of Sargeant Memorial Collection, Norfolk Public Library.*

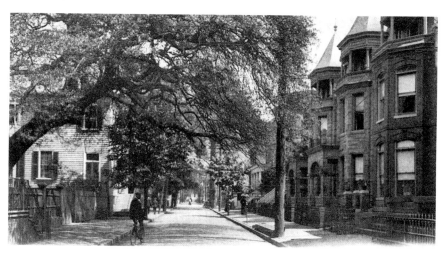

within Norfolk's trade and industry. John Cary Weston, for example, was a notable businessman from the Great Bridge Lumber and Canal Company. His neighbor George W. Roper was the founder of the Norfolk Shipbuilding and Dry-dock Corporation. Roper's 1901 home was built on his success, as were the two subsequent lots he purchased down the street for his two daughters. The Grandys made a remarkable contribution to old Norfolk on Freemason Street, just a few lots from their own home. They loaned the plot of land used to build the city's first free library. Funded through monies donated by the alpha-philanthropist Andrew Carnegie, plans for Norfolk's first free public library began in 1901 by a Boston architect in the Beaux Arts style, one very typical of the turn of the century. This building remained in service as the main library until the 1960s.[69] Down neighboring Bute Street, the majority of Norfolk's finest families resided. John S. Pickett, a descendant of one of Norfolk's better-known Civil War families, owned a row of town homes built in 1891 that contained many members of his family. Pickett himself financed these residences through his success as the owner of a local oyster packing company, along with the wealth passed down to him through his family lineage. Farther down the street was William S. Wilkinson, a manager of the Norfolk Clearinghouse

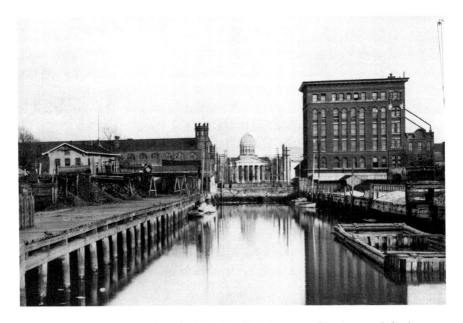

A view looking east near modern-day West City Hall Avenue at City Armory (left), the courthouse (center) and Norfolk's first modern office building (right). *Courtesy of Sargeant Memorial Collection, Norfolk Public Library.*

Association and a prominent local bank, as well as local dry goods merchant and cotton factor Joseph W. Perry. Evidence of the expansion of railroads can be found in the home of William W. Chamberlaine, who worked for the Seaboard and Roanoke Railroad and the Electric Company of Virginia. S.Q. Collins and John B. Lekies also resided in the area and were partners in a sawmill business. Lekies became very wealthy and currently has one of the largest mausoleums in Norfolk in Elmwood Cemetery.

Closer to the waters of the Elizabeth River lies Botetourt Street, where many prominent families resided. Of all the beautiful historic homes in the area, the home of Dr. William Boswell Selden is by far the most intriguing. Built in 1807, it is a prime example of an early nineteenth-century country home. Its claim to fame lies in its history with the War Between the States. During the conflict, Dr. Selden's home was occupied by the Union and its forces. They enjoyed the location so much that they turned it into their headquarters for the duration of their occupation. Perhaps they stayed for the view, which is phenomenal, or its easy access to the waterway. Regardless, the home continues to be a major place of interest for local Civil War enthusiasts. By 1893, the waterway was further appreciated with the establishment of the Norfolk Boat Club. Among the many watersports appreciated here, rowing remained the most popular. It is easy to imagine many of Norfolk's prominent men engaging in such sports on a warm summer day.

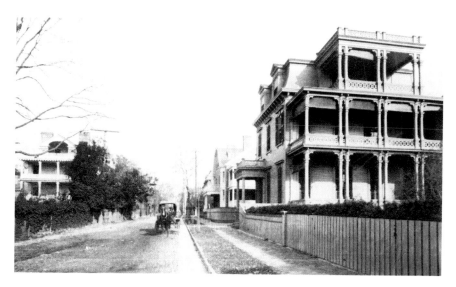

A view down Botetourt Street looking north toward Freemason Street. The residence of C.W. Grandy is on the right. *Courtesy of Sargeant Memorial Collection, Norfolk Public Library.*

A riverside view of the Norfolk Boat Club. *Courtesy of Sargeant Memorial Collection, Norfolk Public Library.*

The origins of these streets of the Freemason and Downtown Districts are fairly typical, and many have names rooted in English royalty and aristocracy. For example, Duke Street was named for the Duke of Cumberland; Bute for the Earl of Bute, John Stuart; and Charlotte for the consort of George III and the Duke of York, Queen Charlotte. Others are named after notable Norfolkian citizens, such as Brambleton Avenue, which was created on the farmland of George Bramble.[70] One of Norfolk's distinguished lawyers, Littleton Tazewell, became the inspiration for Tazewell Street. Similarly, Boush Street was named for the city's first mayor, Samuel Boush.[71] The city's oldest road is Main Street, which is near Norfolk's Plume Street, an area named after a wealthy eighteenth-century man, William Plume.[72] The most intriguing street continues to be Freemason, which to this day contends to be one of the only, if not the only, Freemason Street in the country named after a real Masonic lodge. Much of what is called Freemason Street today was originally referred to as Grafton Street but changed names during

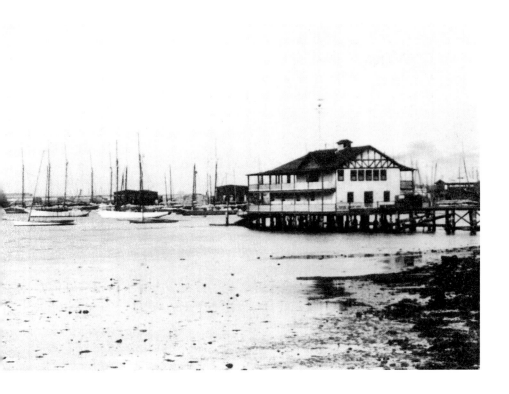

the nineteenth century.[73] Three Masonic halls in total lined this street throughout its existence, making it a cultural oddity.[74]

Many of the city's wealthiest families who resided in these areas gained their stature through success in banking. Among the banks founded by 1900 were the Merchants and Mechanics Savings Bank of 1851, the Citizens Bank of 1867, the Peoples Bank of 1867, the Marine Bank of 1872 and the Norfolk Bank of 1885.[75] Some of the more notable families involved in banking were descendants of the Taylor, Grandy, Sharp, Walke, Toy, Loyall, Dey, Ramsay, Hardy, Nash and Leigh families.[76] Many men in these social circles became accomplished doctors, including Southgate Leigh, Robert Tunstall and William Selden, influencing the development and advancement of the medical profession. Dr. Southgate Leigh kept an office in the Talbot family home, where he continued to practice for many years.[77] Dr. Selden began practicing during the 1830s and continued into his old age.[78] Dr. Tunstall was also a well-respected physician, having studied under Dr. Baylor, one of the city's leading medical professionals.[79]

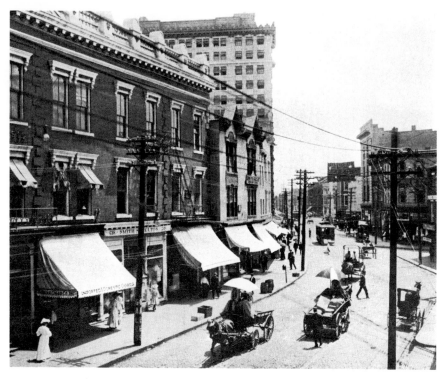

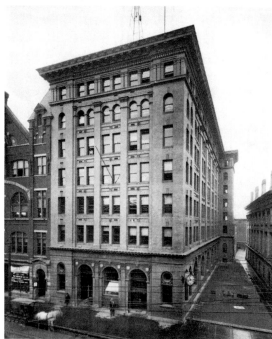

Above: A bustling scene on Main Street. *Courtesy of Sargeant Memorial Collection, Norfolk Public Library.*

Left: The exterior of Citizen's Bank Building. *Courtesy of Sargeant Memorial Collection, Norfolk Public Library.*

Education in Nineteenth-Century Norfolk

Until the late 1880s, Norfolk's education system consisted of a series of privately run institutions. Many female-only schools competed for both enrollment and prestige throughout the downtown area. Most were owned by learned women of the neighborhood and focused primarily on teaching young ladies the genteel way of the ideal Victorian woman. On College Place, a street in the Freemason District, the Norfolk College for Young Ladies began instructing the young women of the neighborhood. At a building on the corner of College Place and Granby Street, over one hundred students received an education from Norfolk's learned elite. In 1899, though, this particular school closed its doors for unknown reasons. The building it occupied was reinvigorated as the site of the downtown Algonquin Hotel.[30] Over time, the area was converted into storefronts.[31] Down the street was the Leach-Wood Seminary, another popular rival institution.[32] Phillips and West's school for girls on 186 Freemason Street was also immensely popular and was the school the Hunter girls attended as young ladies. Men's schools were conducted by educated men from old families, such as Tunstall, Webster, Gatewood and Galt, among others.[33] Women's schools were conducted by men of upstanding moral character and by the wives, sisters and daughters of men of similar levels of prestige. Some other notable educators were Reverend Aristides, Mary E. Rowland, Leonidas Smith and Julia Robinson, among others.[34] Aristides and Smith ran a very fashionable Academy for Young Ladies on Holt Street that was later taken over by Father O'Keefe, a representative of St. Mary's Church. The building itself witnessed many changes over the years, eventually coming under the ownership of a Roman Catholic Brotherhood by the twentieth century.[35] By 1883, Norfolk had witnessed the addition of higher education opportunities for the African American community. At this time, the Norfolk Mission College was created by the General Assembly of the Presbyterian Church. This institution continued for almost thirty-five years, closing its doors in 1916.[36]

Libraries were once a luxury only available to the elite. Private educational institutions and clubs often held their own libraries, containing volumes pertaining to their wide range of subjects for study. Affluent men and their families grew personal libraries as well, filled with more particular books concerning their own personal interests in subjects like natural science, theology, philosophy, history and literature. By the turn of the century, libraries were becoming more of a public

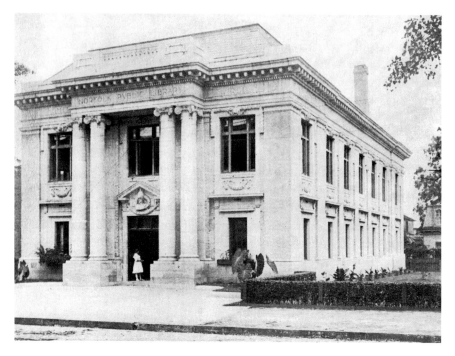

Norfolk's Carnegie Library on Freemason Street. *Courtesy of Sargeant Memorial Collection, Norfolk Public Library.*

necessity. Norfolk caught on to this trend and completed construction on the city's aforementioned first free public library in 1904 at 345 West Freemason Street.

The library took one year to complete, and its leadership appointed John Roper as the first president upon opening its doors. There were no celebrations or parades celebrating its opening but, rather, a calm beginning to its decades of utility. Its patrons were happily supplied with over ten thousand books once they became official members of the library. Like every other public institution of the period, membership was available only to a select group of individuals, and race was certainly a factor. The library was beloved and well used during its time in the Freemason District.

Apart from private institutions and public libraries, schooling was also provided on a more individual basis. Young men and women could be subjected to personal tutoring in whatever subjects their parents felt necessary. Often, the arts became the most highly tutored areas. Like apprenticeships, tutoring allowed for individuals to master one specific

craft. Personal tutors had existed in America since before the nation was born and continued to maintain their societal importance until the introduction of free public education for all. Tutoring experienced a resurgence in the 1960s, when integration in the school system caused many white families to pull their children from school in favor of a racially secluded education. Norfolk has quite the history with this subject, one that was solidified in the mid-nineteenth century. At 227 Freemason Street, Lizzie Moore advertised her services as a music teacher. Perhaps the Hunter family used her services for their two daughters, as her location was in proximity to their home. There were certainly other tutors as well, but many relied on the recommendations from their affluent clients to maintain and grow their pupil population rather than on advertisements. Well-recognized tutors were often offered positions within the halls of the city's best schools for young ladies. As all were aware, education in Norfolk at the turn of the century was as much a designator of social class as any other institution.

Living Luxuriously

Norfolk's elite participated in various activities during the late nineteenth century. At the forefront were those that allowed for innovative or provocative explorations of culture. Of all the leisurely activities available at the turn of the century, lectures were by far the most popular. Men and women alike attended lectures concerning a wide range of topics, generally given by area scholars. Of course, women usually listened and did not participate, but men were often actively involved in audience discussion. These lectures could be held at local universities, libraries, churches or public meeting halls. The 1894 directory for Norfolk lists Christ Church's lecture room as a possible area for such activities. Earlier areas, such as the Lyceum downtown, had also been built for such purposes. Lectures, next to dinners and dancing, remained one of the high points of Gilded Age leisure.

Aside from lectures, many other social activities were available to Norfolk's citizens. Afternoon tea was a staple activity in the Victorian lady's social diet, so the availability of tea was crucial to maintaining one's station. To obtain such products, locals could visit the East India Tea Company on 189 Church Street. Depending on social status, individuals

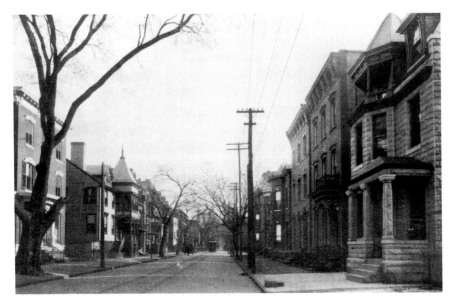

A view down Bute Street. *Courtesy of Sargeant Memorial Collection, Norfolk Public Library.*

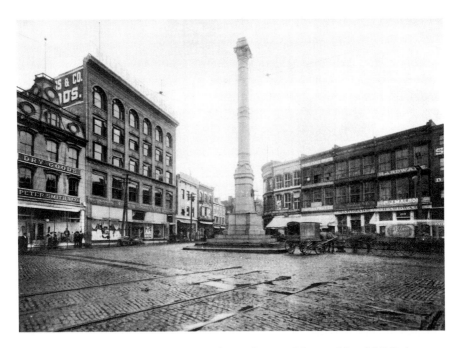

A view of East Main Street at Commercial Place. *Courtesy of Sargeant Memorial Collection, Norfolk Public Library.*

in need of more tea would either visit the business themselves or send their servants. A little outside the immediate downtown area, the business surely would have been patronized by the elite and would have thrived in Norfolk. Closer to the business district, the Great Atlantic and Pacific Tea Company at 39 Market Square would also have done a great deal of business with local consumers. Other provisions for entertaining could be purchased from nearby grocers, such as that of A.J. Whitehurst & Bro. Grocers at the corner of Brewer and Bute Streets.[87] Dozens of grocers existed, making it one of the more competitive businesses downtown. Male society was, of course, not complete without access to local breweries and their products. An agency of the Anheuser-Busch Brewing Company had a place on City Hall Avenue where much business was done.[88] Throughout the Tidewater area, many other breweries supplied the needs of thirsty Norfolkians.

According to resident Emma Blow Freeman Cook, in turn-of-the-century society, "the three D's were taboo; dress, domestics and disease were not discussed in good society, and the mention of money was 'beyond the pale.'"[89] This was certainly true, but outward displays of one's wealth were always in order. As a result, Norfolk's shopping areas were ripe with fine clothing stores, jewelers and others. Paul-Gale-Greenwood Company Jewelers offered its ornamental services at the corner of Granby Street and City Hall Avenue downtown, while those opting for a more exotic pastime could indulge at Norfolk's palatial Turkish Baths & Rooms. Still others could continue to patronize local tailors and clothiers, such as Ames, Brownley & Hornthal, Inc., Dry Goods, Millinery and Ladies Garments, later known as Ames & Brownley Department Store. Those in need of pen and ink could visit the local stationery shop on Granby Street, Norfolk Stationery, the primary supplier of all things correspondence. The more adventurous lot could spend time at the city's roller-skating rink at the corner of Tazewell Street during the winter months.[90] For the children, there was Mr. Tripple's candy shop at the corner of Granby and Charlotte Streets.[91] Norfolk's downtown district offered something exciting and pleasurable for all its residents.

Other avenues of entertainment could be found in the theatrical and musical realms. The Van Wyck Academy of Music remained a local favorite for many decades. Located on Main Street, the theater was capable of housing 1,600 audience members, with the addition of hundreds more in standing room.[92] As of 1893, there were no public displays of fine art, but many affluent families housed personal collections of indescribable worth. These paintings, sculptures and the like could be viewed only by invitation. Much later in the twentieth century, the

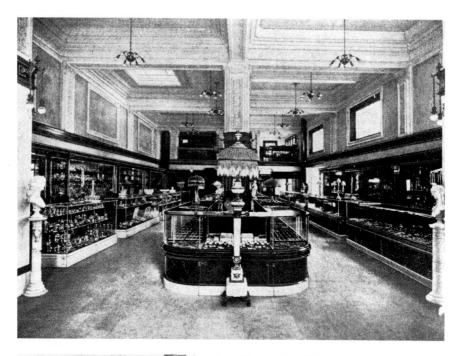

Above: The interior of Paul-Gale-Greenwood Co., Inc. Jewelers. *Courtesy of Sargeant Memorial Collection, Norfolk Public Library.*

Left: The exterior of the Turkish Baths & Rooms, located downtown on Atlantic Street. *Courtesy of Sargeant Memorial Collection, Norfolk Public Library.*

Chrysler Museum of Art was created to house many worldly objects of value. Art remained much more of a private institution than a public one prior to this point. Music could also be experienced at local churches, such as Christ's Church, St. Luke's Church, Freemason Street Baptist Church, Epworth United Methodist Church and others. Freemason Street Baptist Church became the second-oldest edifice built in Norfolk when its foundation was laid in 1848. The Masons aided in its beginnings, having laid

The exterior of Ames, Brownley & Hornthal, Inc. Dry Goods, Millinery and Ladies Garments. *Courtesy of Sargeant Memorial Collection, Norfolk Public Library*

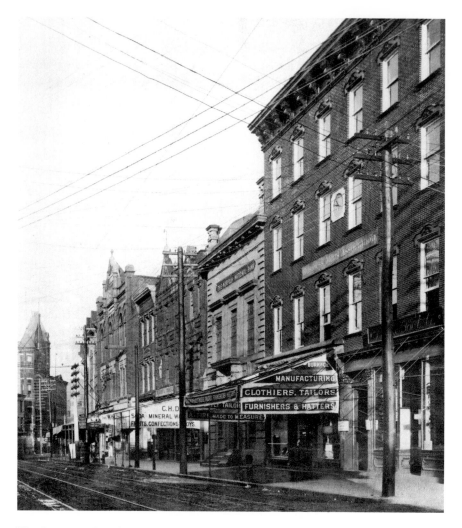

The downtown shopping experience on East Main Street, Norfolk. *Courtesy of Sargeant Memorial Collection, Norfolk Public Library.*

the cornerstone as it was built. Done in the Gothic architectural style, this house of worship was located at the corner of Freemason and Bank Streets. At the corner of Freemason and Boush Streets was Epworth United Methodist Church, completed in 1894 in the Romanesque Revival style. Emma Blow Freeman Cook described a particular scene as such:

> *Old Christ Church on the corner of Freemason and Cumberland Streets, with its far-famed choir of exquisite voices, beautifully trained by the beloved*

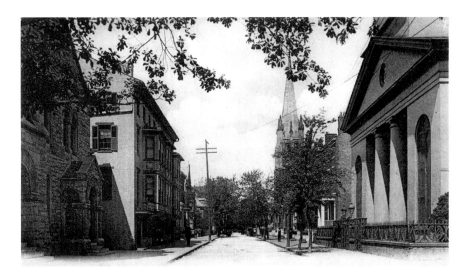

A postcard depicting the view down Freemason Street at the turn of the century. *Courtesy of William Inge.*

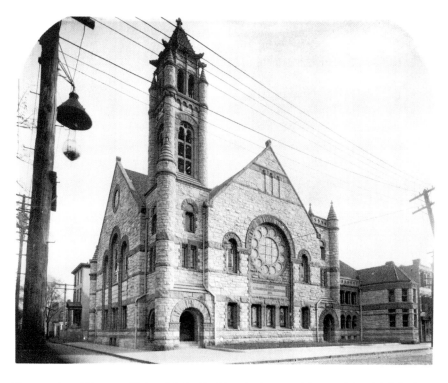

The exterior of Epworth United Methodist Church. *Courtesy of Sargeant Memorial Collection, Norfolk Public Library.*

The interior of Epworth United Methodist Church. *Courtesy of Sargeant Memorial Collection, Norfolk Public Library.*

> *Professor Masi, was at one time the very heart and soul of the town. The handsome Tiffany memorial windows shed soft colors throughout the stately old building, and the arch of the chancel was the admiration of all lovers of the beautiful.*[93]

These and other churches simultaneously offered socialization and solitude through their congregations and their music. Churches, as throughout history, remained the heart and soul of the community, a place where one hoped to see and be seen. At the turn of the century, churches remained integral parts of the social makeup of thriving cities and towns.

Other public buildings and areas of note are the public marketplace, the custom house and the post office. The marketplace was located on the far end of Main Street, where the old fish house thrived.[94] Carts of fresh-caught fish, oysters and other types of seafood were piled and sold to the city's inhabitants. The custom house, originally located on west Main Street, remained a vital part of the business district downtown throughout the nineteenth and twentieth centuries.[95] The post office was originally on the

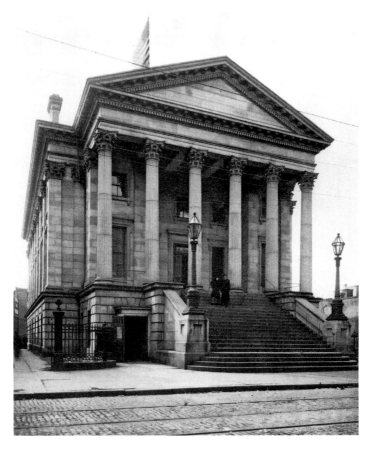

The exterior of the customs house on Main Street. *Courtesy of Sargeant Memorial Collection, Norfolk Public Library.*

corner of Main and Commerce Streets, a building apart from the custom house. In 1857, though, a building was constructed at the corner of Granby and Main that housed both the post office and the custom house, the former on the bottom level of the building and the latter one floor above it. The building was bold architecturally, having been constructed in granite with large Corinthian columns. The site produced a domineering presence in the business district among the many cheerful, thriving industrial centers in the area.

Chapter 3

A HOME FOR MR. HUNTER

A Case Study of Décor and Decorum

About the Architect: W.P. Wentworth

Though little is known about the personal life of William Pitt Wentworth, records indicate he was born in 1839, lived in Vermont and worked out of Boston. In the short fifty-seven years of his life, Wentworth was responsible for designing a variety of lesser-known private, public and ecclesiastical works, among which is the Hunter House Victorian Museum.[96] He is credited with designing three works in the northern and two in the western United States, all but one of which is a place of worship. In New York, he designed Trinity Episcopal Church and Parish House in Watertown and the Church of St. Lawrence in Alexandria Bay. Additionally, he is responsible for the Medfield State Hospital in Medfield, Massachusetts. Moving westward, Wentworth designed the People's Unitarian Church in Ord, Nebraska, and St. George's Episcopal Church in Leadville, Colorado.[97] Locally, Wentworth served as architect from 1891 to 1892 for St. Luke's Church in Norfolk, which was located at the corner of East Bute and Granby Streets. By 1921, though, the church had succumbed to fire, and the Walter P. Hoffman Federal Building later graced the property. As he died in 1896, it is very possible the Hunter House Victorian Museum was his last completed work.

While what is known about Wentworth is limited, even less is known about his relationship with the Hunters. It is probable Hunter was referred to Wentworth as a result of his work on St. Luke's Church. The family worshipped there until the church combined forces with another local place

of worship, forming Christ and St. Luke's Church. In all likelihood, Mr. Hunter was impressed by his work and chose to employ him in the designing of his own home along with builder Elbert Tatterson. For the lavish sum of $20,000, the Hunter House was completed.

Based on Wentworth's aesthetic and the period in which the home was built, it is not surprising that the Hunter House was crafted in the Richardsonian Romanesque style, which is synonymous with the Romanesque Revival movement of the period.[98] Richardsonian refers to a very prominent Victorian-era architect, Henry Hobbes Richardson, who is noted to have worked on the private homes of many of America's nouveau riche during the nineteenth century. Richardson typically used brownstone, granite, turrets and curved archways as his main design elements, all of which are present in the Hunter family's three-story town home.[99] Archivist Cheri Gay describes the grandiose style best: "Although Romanesque buildings were mainly public ones, because they were built exclusively of stone and expressed a permanence associated with municipal buildings, churches, libraries, etc., some of the very rich commissioned these palatial or chateau-like houses, which had, at the same time, a rustic air to them."[100]

While the Hunter family home is not considered palatial or chateau-like, the rustic nature of the building is evident to all who encounter it. Hunter, like many Victorians, chose to have his home built in this style to outwardly display the social and economic status of his family. In other words, he quite literally wanted to share his good fortune with the local community. There would be no doubt in anyone's mind; the Hunters were an integral part of the wealthy, cosmopolitan class in Norfolk society.

The Hunter Family

Born on December 19, 1850, James Wilson Hunter married eighteen-year-old Lizzie Ayer Barnes at St. Luke's Church in Norfolk in 1877 with "consent of [the] lady's mother."[101] On April 30, 1878, the couple welcomed their first child and only son, James Wilson Hunter Jr., to their family.[102] On October 10, 1880, the family expanded to include Harriet Cornelia, followed by her sister Eloise Dexter on February 2, 1885.[103] When the family moved into their new home on Freemason Street, the children were nine, fourteen and sixteen years old. None of the Hunter

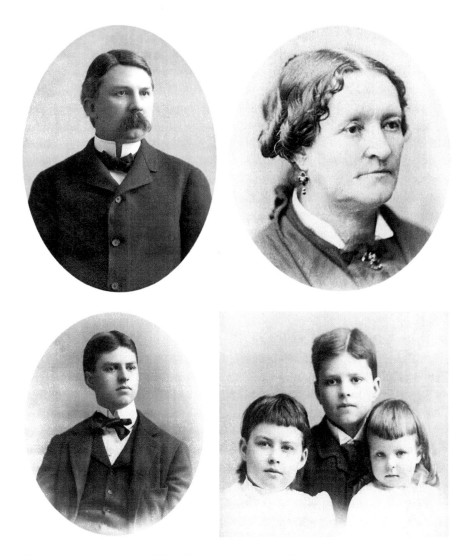

Clockwise from top left: James Wilson Hunter. *Courtesy of the Hunter Foundation;* Lizzie Ayer Barnes Hunter. *Courtesy of the Hunter Foundation;* The Hunter children: Harriet (left), James Jr. (center) and Eloise (right). *Courtesy of the Hunter Foundation.* Dr. James Wilson Hunter Jr. *Courtesy of the Hunter Foundation.*

children married or had children of their own, and all remained in the home throughout the duration of their lives.

While residents in the home, the children were well educated and became very involved in the local community. Harriet and Eloise were both educated at the Phillips and Wests' School for Girls in Norfolk,

where they were taught the subjects deemed appropriate for young ladies of their standing. They were regular attendees at Sunday service at nearby Christ and St. Luke's Episcopal Church in Norfolk once the two churches combined forces. They were also very involved in genealogical and heritage-based organizations like the Daughters of the Confederacy, Daughters of the American Revolution and the Huguenot Society.[104] They remained active in all these organizations until their deaths in the mid-twentieth century.

James Wilson Hunter Jr. experienced a very different life than Harriet and Eloise. James was educated at the Episcopal High School in Alexandria, Virginia, as a youth. When the family moved into the home, James was attending this school. Following high school, James attended the University of Virginia in Charlottesville, Virginia. Here, he received a bachelor of arts and master of arts, both in 1899. He also did more graduate work at the University of Virginia, graduating with his medical doctor (MD) degree in 1901. He then attended Harvard, where he pursued his postgraduate education. By 1901, he had become a certified doctor and was categorized as a general practitioner, cardiologist and radiologist.[105]

James continued his blossoming career under the guidance of local doctor Southgate Leigh, whose family was well known and loved and whose aunt Sara Leigh now has a hospital named after her in Norfolk. Once he finished this period of professional guidance, James opened his own practice in downtown Norfolk, where he remained for the majority of his life. His medical practice was only interrupted as World War I broke out and he joined the army. He is listed as a member of the Medical Advisory Board, no. 3, which indicates he was active from May 18, 1917, to March 31, 1919. During this period, he also served as captain of the Medical Corps from November 5, 1918, to January 6, 1919.

When not involved with his practice, James, like his sisters, gave much of his time to genealogical, service and heritage-based organizations. He was part of the Society of the Cincinnati, the American Legion and the Association for the Preservation of Virginia Antiquities, among others. All three children enjoyed researching their heritage and tracing their family genealogy, as well as reading and discovering nature. They probably spent many afternoons together engaged in these activities as both children and adults. Seeing as they spent their entire lives together, it would be a mistake to suggest they were not close.

By 1931, James Wilson Hunter had passed away, followed by his wife, Lizzie, in 1940.[106] Prior to his mother's death, James Wilson Hunter Jr.

suffered a heart attack and passed away in 1940.[107] James had been away in Hot Springs, Arkansas, making him the only family member who did not pass away in the house. All the family members were laid out in the front parlor, as was custom, and buried in Elmwood Cemetery. By the end of that same year, Harriet and Eloise became two sisters living alone in the big city.

The loss of their family members certainly did not hinder the sisters' continued involvement in many philanthropic, genealogical and social organizations. Harriet and Eloise remained active in the Daughters of the Revolution, Daughters of the Confederacy and various other organizations until their deaths in 1958 and 1965, respectively.[108] "The girls," as many docents affectionately refer to them, liked to stay busy, as evidenced by the countless social clubs and organizations in which they took part. They were often in the public eye during their later years, something the earlier Victorians would have gasped at and certainly gossiped frequently about. Free of the social chains the Victorian era had placed on their sex, the Harriet and Eloise of the 1950s would not have resembled the Harriet and Eloise of the 1890s and 1900s. They would have experienced much more autonomy in their later years.

Visitors often stand awe-struck when told the sisters never married and even more so when they discover James did not marry either. Unfortunately for museum staff and visitors alike, the reasons for this choice have never been determined. The Hunters chose to have their home live on as a museum of decorative arts and furnishings from the Victorian era, giving little credence to the need to preserve their own private history. There are no diaries, letters or an abundance of other correspondence. Like the choice the siblings made to never marry, they made the choice to keep the details of their private lives private. As interpreters of the home, the museum staff chooses to respect those choices and focus on the exquisite pieces they maintained for our viewing pleasure and let the secrets of their personal lives rest with their souls.

The First Floor: Calling, Entertaining and Leisure

As visitors enter the Hunter family's home, they are captivated by the solid oak doors that greet them. The interiors of the home are an eclectic mix of solid woods, William Morris–inspired wall coverings and period reproductions of carpeting, draperies and some upholstery and light

fixtures. Four types of glass can be found on the first floor alone: lead, colored, beveled and stained. Walking through the rooms, guests will pass encaustic and ceramic tiles, hand-carved woodwork and inlaid brick detailing. The visual complexities that stimulate the senses have been placed there purposely, to give the feeling guests are entering into the high Victorian period complete with lavish fabrics and luxuries only the wealthy could afford.

Interior design gained popularity during the Victorian era, as wealthy Americans like the Vanderbilts and Carnegies concentrated intensely on the messages they wanted the interiors of their homes to send to visitors. European-inspired furniture and oriental details became extremely popular, as did the inclusion of the wallpapers of well-known designer William Morris. A leader of the nineteenth-century British Arts and Crafts Movement, William Morris was critically acclaimed and highly sought after.[109] The Hunters may have used Morris in their own designs, but the specifics of such design elements are currently unknown. Today, period reproductions of some of Morris's more popular and interesting designs can be found on the majority of the walls in the rooms in the museum, as well as on a few ceilings, in addition to fabric tufting in the library. "Gaudy" or "busy" were not words in the Victorian vocabulary. Often described as early hoarders, Victorians loved to collect and often displayed these collections in their more public rooms, such as parlors and libraries. The front parlor in the Hunter House is the perfect place to experience this affinity for collecting.

As visitors walk into the parlor, they pass the Hunter family's calling card receiver, a silver dish meant to hold the cards of old friends and new acquaintances. The art of calling became one of the ripest examples of social propriety during the Victorian era. As social custom dictated, there would be a time for calling during which each upper-class lady would receive guests for up to thirty minutes at a time, although it was deemed much more appropriate to stay a mere fifteen minutes.[110] When calling, guests would present calling cards, generally printed with their names in a plain font that also designated the title of the caller. Calling cards had their own language—one in which the hostess could readily determine the purpose of the call, whether the callers came to call themselves or sent a servant and even the urgency of the matters they wished to discuss. Judith Flanders best explains the circumstances surrounding calling customs. She states, "Calling was obligatory the day after a dinner party, an evening party, or any other sort of entertainment, if there was illness

A collection of calling cards in the front hall, Hunter House Victorian Museum, Norfolk. *Courtesy of Cathy Smith Photography.*

in the house [and] after a death."[111] In actuality, almost every social event imaginable involved calling on a particular member in society.

Calling was most important, however, when seeking an introduction. Victorians employed very specific rules regarding making an acquaintance. A person seeking an acquaintance would bring his or her card to the home of the desired person and leave the card with its corner turned down, which indicated a personal call had been made and the card was not delivered by a servant. It was then up to the recipient of the call to determine the nature of the relationship. It was expected for personal calls to be returned in like; if an in-person call had been made, the recipient should also make an in-person return call to the caller. If returned with an impersonal call, which generally could be done by having a servant drop off the card, then the recipient was made aware the return indicated the desire for a distant acquaintanceship, nothing more. In effect, calling cards quite literally determined the social structure of high society.

The Front Parlor

By the 1880s, the woman has become a demigoddess of art and morality,
and the parlor is her temple.
—*Elan and Susan Zingman-Leith, "The Secret Life of Victorian Houses"*

Once each guest had presented his or her card and was invited to be received by Mrs. Hunter, he or she would be welcomed into the museum's front parlor. This grand oval-shaped room is covered in hues of rosy pinks, deep reds and hints of green and gold. The reproduction wallpaper is modeled after an 1887 William Morris design called Acanthus Leaf Pattern. The border paper that bridges the gap between the wallpaper and the ceiling is also a William Morris pattern called Bird and Anemone, which dates to 1882. Oriental pieces, probably purchased by the Hunters at the World's Fair or even commissioned during one of their travels, can be found at the corners of the room. The Chinese étagère, more commonly used as a display cabinet, is one of the more striking pieces in the room. Crafted during the 1890s, this piece is made of rosewood and once held a small collection of ivory carvings. An exquisitely crafted settee is artfully placed below a mirror to present an opportunity for socializing—an art form certainly not lost to the Victorians. This settee is not to be confused with the ominous "fainting couch" that could be found in many Victorian houses. The fainting couch, quite literally, was employed to aid those women suffering from extremely tight corsets. What price was too high for true beauty? No price was too high, of course. To the Victorians, image was everything. For this reason, only the family's most unique, expensive furnishings and collectibles are displayed in the front parlor. For a guest in the home, the parlor sets expectations for the offerings of the family both within the home itself and in other social gatherings. An observer of this parlor would certainly leave with the impression that the Hunter family members were well traveled, fashionable and solid members of Norfolk's high society.

The transformation of the parlor during the Victorian period is in itself notable. Prior to the nineteenth century, social gatherings that took place in a formal parlor would have appeared much different than those that occurred during the height of the Victorian era. The main difference was the focus on interior design and decorating. Prior to the nineteenth century, furniture was arranged along walls, out of the way of general foot traffic. During the nineteenth century, however, furniture arrangement fell into the category of "womanly duties" in the Victorian household. Women were encouraged to

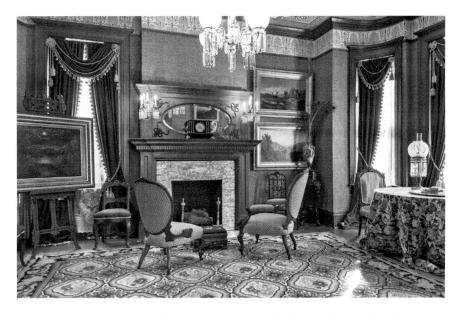

The front parlor, Hunter House Victorian Museum, Norfolk. *Courtesy of Cathy Smith Photography.*

design arrangements that stimulated polite conversation. As a result, settees and exquisitely crafted chairs were gathered together in the nineteenth-century parlor for women to socialize and craft. This is the period in which the sewing circle literally took its rounded shape as women socialized and did their needlework simultaneously.[112] In addition to the conversational groupings of sitting areas, tables were also part of the interior landscape. Each parlor would contain a sort of center table on which a lamp would be placed for reading. This piece would serve many purposes, as it would transform into a place for tea during calling hours and even a surface for the playing of parlor games should there not be a back parlor in the home or if the guests outnumbered the available space in the room.[113]

The parlor also became the space in which Victorians could display their collectibles. Victorians were the first true collectors, primarily as a result of innovations in travel. Victorian bed-and-breakfast owners, scholars and enthusiasts Elan and Susan Zingman-Leith make the vital observation that "inexpensive travel by railroad and steamships permitted a fad for souvenirs and exotica."[114] It is evident in the Hunter House that the Hunter family fell into this category of collectors. Not only did they have the previously stated ivory collection in their Chinese étagère, but they also collected souvenirs from their travels. Their old steam trunks—a few of which can be viewed on

display in the gift shop today—are worn down from the many trips they took throughout their lifetimes. Many of the collectibles that resulted from their trips are not currently displayed in the front parlor of the home, but that is not to suggest they never would have been. There are Spanish editions of the *Ladies' Home Journal*, wall hangings of the Virgin Mary from New Mexico and English and Japanese porcelain dishes and teacups, among other interesting souvenirs and collectibles. Collections served not only as status symbols but conversation pieces as well. And what better place to socialize than in the cozy seated circles of the front parlor?

The Back Parlor/Library

Passing through the front parlor to the next room, visitors would be received in the back parlor, more often referred to as the library. The Hunters were avid readers and quite the scholars, often spending their leisurely hours researching their ancestry, history and the natural world around them. While James Hunter Jr. attended boarding school, the University of Virginia and Harvard, Harriet and Eloise did not receive a college education. They did, however, receive an education that prepared them for life in high society. They became well versed in literature, languages, homemaking and the arts. This education allowed them to take advantage of the many works present within their family library. Both daughters joined the Daughters of the American Revolution and Daughters of the Confederacy; therefore, they may have had a hand in researching their genealogical background and in documenting their family's prominence as one of the nation's founding families.

A glimpse at their collection reveals this fixation on determining their family origins. Works on the Jamestown expedition, collective essays on founding families and local histories allowed the family to trace their ancestry to the founding of Jamestown itself. A picture of their founding relative can be viewed upstairs in James Jr.'s office, the perfect reminder of the legacy he should aspire to create for his family name. Their library also consists of many transcendentalist works, most of which concentrate on nature as an extension of the spiritual world. The shades of green throughout the wall coverings, draperies and fireplace in the room reflect this affection for the natural world. The fireplace itself is adorned with ceramic tile featuring a beautifully crafted depiction of the three muses, an obvious ode to the

A HOME FOR MR. HUNTER

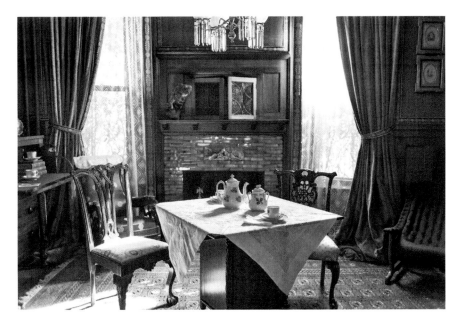

The library/back parlor, Hunter House Victorian Museum, Norfolk. *Courtesy of Cathy Smith Photography.*

Greco-Roman world the Victorians adored and frequently emulated in literature and the arts.

Most of the pieces in this room are of the Early Empire Period, which spanned from 1815 to 1845 and predated the home itself. The secretary is one of the oldest documented furniture pieces in the house. It is particularly interesting because it consists of two different parts. The base of the secretary has been traced to a maker in the Tidewater area and dates to 1820, while the top half resembling a hutch was added in 1830. This is not uncommon in antique furniture, as many families sought to reuse heirloom pieces in one form or another. This secretary currently houses a small portion of the Hunter family's collection of books, while the angular built-in bookcase on the opposite wall harbors another larger portion. The collection displayed in the back library accounts for approximately one-fourth of the Hunters' total collection. Their other books are stored in an auxiliary library on the third floor of the home, wherein the family actually may have once stored these books in the early twentieth century.

Other pieces on display in the home are a pair of Chippendale side chairs from the 1870s, a post–Civil War campeachy chair and a game table. The campeachy chair—or student lounger, as it is often called—is

made with a horsehair cover. It reclines in a manner conducive to reading, which obviously gives the chair its nickname. The chair dates to sometime between 1870 and 1880. The Chippendale chairs are placed with the family game table, which is done in the Early American Empire style. The back parlor or library was often the area designated for recreational time for the family members. The children and their parents may have spent many rainy afternoons around this table playing cards and tabletop games or reading selections from their library. The girls spent time delving into arts and crafts in this room, in addition to stitching and studying. One example of their leisurely time that has survived is a Victorian scrapbook. The Victorian version of a scrapbook is not something today's crafters would recognize as a typical scrapbook. With the absence of mass photography, Victorian ladies were not altogether capable of crafting our modern scrapbook. Instead, they created pages filled with elements of interior decorating and design. Ladies would carefully cut and paste images from ladies' magazines into the pages of blank books, placing cutouts of furniture within different parts of the created "rooms" and creating color schemes and patterns in the process. This type of activity was meant to allow the young ladies to develop a sense of style they could take into their future lives as wives and homemakers. Having an eye for style was deemed just as important as having a mind dedicated to virtuous thoughts. The home was an outward representation of everything a Victorian woman represented, and her style needed to reflect that sentiment.

A shallow cabinet above the fireplace causes visitors to experience a brief moment of confusion. A mere few inches deep, the purpose of the cabinet appears virtually nonexistent. The origins of this particular cabinet are quite perplexing, so much so that the staff of the museum has searched for answers to solve the riddle of the strange cabinet. The consensus became that the cabinet probably held Mr. Hunter's brandy, although occasionally the theory is presented that it may have held the family Bible instead. The latter is much less likely, as it makes very little sense to have such a precious, flammable item in direct contact with a fireplace. More likely, the cabinet was the perfect space for Mr. Hunter to hide and warm this popular social beverage due to its height away from the children and its ability to conceal the bottle from clear view. The cabinet, though, still remains one of the more unique oddities found in the Hunter home.

But of course, there are also the two stuffed animals in the library and dining area that raise some eyebrows. On the secretary in the library, a well-preserved barn owl stares off into the distance, while a duck sits awaiting the

A witness to the rise of taxidermy, a barn owl sits in the library, Hunter House Victorian Museum, Norfolk. *Courtesy of Cathy Smith Photography.*

rush of water in the sink in the china cupboard. Both of these animals have been preserved through the art of taxidermy, a practice employed by the Victorians that also became an element in interior decorating.[115] Victorian author Oliver Davie best describes the nature of taxidermy as an art form, stating that it "attempts to reproduce the forms, attitudes and expressions of animals as they appear in life."[116] Davie seeks for readers to understand the beauty behind what some call a grotesque hobby. For the Victorians, the beauty in taxidermy needed no explanation. Stuffed animals were put on display much like one would display a teacup collection or framed artwork on the walls.[117] Taxidermy reached its golden age under the Victorians, who extended its uses to "resurrecting" dead pets. The Victorian fascination with nature often bordered on the morbid side of life, as evidenced in some of the Victorian park cemeteries of the period. Graves were adorned with ornamentation reminiscent of specific plants, shells and other items, each with their own symbolic meaning. These symbols of slumber were simply another extension of the interest in nature many Victorian families, like the Hunters, exhibited.

The Dining Room

Author Susan Williams best describes the importance of the Victorian dining room, stating, "Furnishing a nineteenth century dining room was a task of far-reaching social significance, since an entire complex of ideals and aspirations were made manifest within that room."[118] Hopes and dreams lived and died in the dining room. This was the area in which acquaintances became partnerships, a person's social status either unraveled or solidified and major life decisions were made among family and friends. It is no wonder, then, that Victorians took such care to ensure the ambiance of the room itself commandeered respect and purpose. The Hunters' dining room, with its masculine features and neutral colors, provides a focus for these feelings with a uniquely hand-crafted dining set. Completed in 1895, the solid oak dining table itself is impressive as a piece of custom furniture, adorned with a lion's paw for each of its four feet and carved detailing of a lion's head at the corners of the table. It is believed the dining table and accompanying chairs were designed by the home's architect, William Pitt Wentworth, and then crafted by the same craftsman who completed the paneling in the house. This has neither been confirmed nor denied, but

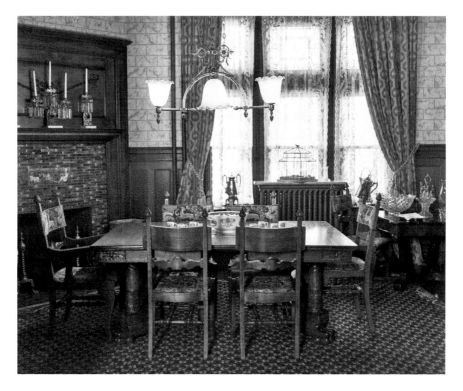

The dining room, Hunter House Victorian Museum, Norfolk. *Courtesy of Cathy Smith Photography.*

continuities within the design and craftsmanship of the set have led to this conclusion. This piece is presented with eight chairs, two of which appear slightly different than the others. Why? These chairs are slightly higher, two inches to be exact. They are clearly designed to be occupied by the man and mistress of the house. Together, they symbolically stand watch over the family at the dinner table, like the lion and lioness watch over their cubs.

The dining room also includes a small china cupboard, within which the Hunter family's best china, linens and serving dishes resided. In larger Victorian homes, the dining area would sit near a butler's pantry, which would also have space for preparing and plating meals for meal service.[119] Although the Hunters did not have this feature, they were still able to entertain. Cocktail parties were a perfectly acceptable form of social gathering for Victorians in the city, and the Hunters almost certainly took part in them. They more than likely hosted them as well in their own home. These parties had rules of their own, most of which were constantly in flux. The Victorians perfected the art of the dinner party, from silverware and serving dishes to sequences of

courses and polite conversation. At the time when the Hunter family moved into the home, dinner service itself had undergone many changes. The buffet-style service used during the early half of the nineteenth century was replaced by plated dinner service.[120] This new service, called Russian service, was made up of "gloved servants who brought each guest measured portions on a plate."[121] As the way food was served began to change, so did the décor at the dinner table and even the food itself. The Victorian era witnessed the transformation and reintroduction of the centerpiece on dining tables. Originally a silver or crystal stand amassed with fresh fruit and nuts, the centerpiece was replaced with floral arrangements as desserts came to be plated rather than presented as part of the décor.[122] Such pieces of silver and crystal can be found on the Hunters' English Edwardian mahogany display cabinet, along with other serving pieces. By 1900, manufacturers began producing ceramics, glassware and silver pieces more frequently and made them more readily available to varying economic classes.[123] Within the half century leading up to that point, families began expanding their collections of serving pieces as a result. The Hunters were undoubtedly one of these families taking advantage of the innovations in craftsmanship and technology that allowed for the increased availability of these materials.

A small alcove with a bay window is located adjacent to the china cabinet, as was traditional in Victorian homes. Many of the larger homes placed a sideboard in this area or had one built in.[124] For the Hunters, this area served as a gateway to the natural world rather than as storage for their dinner service. Within this window, guests were greeted by displays of fresh greenery, most likely handpicked from the family's garden adjacent to the house. This miniature conservatory acted as a reminder of the beauty of nature in an era when industrialization was king. In larger homes, guests of wealthy families could expect to encounter a full-sized conservatory literally built indoors to serve this same purpose.

Of all the pieces in the dining room, perhaps the most amusing is the tilting water pitcher. Patented in late 1860, the silver tilting pitcher became fashionable as classes of luxury obtained access to ice. Families serving ice water to their guests appeared very chic and flippantly wealthy. After all, ice was a fleeting product, barely surviving a few hours before perishing and being rendered utterly useless. For this reason, only the wealthiest in high society attempted to serve it to their guests. Pitchers were often accompanied by ice glasses and other accoutrements. But some would argue ice water was served not just to display wealth but also to express issues of morality. Around the time ice began making its way into middle- and upper-class

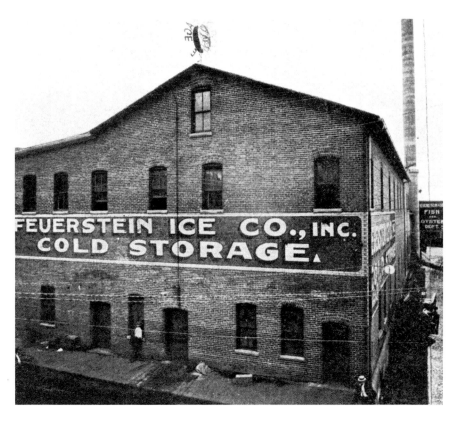

Feuerstein Ice Co., a local institution for those housing iceboxes and serving it at their tables. *Courtesy of Sargeant Memorial Collection, Norfolk Public Library.*

homes, the temperance movement had recently taken root in American cities. Prominent Norfolkian descendant C.W. Tazewell recalls, "At one time a small prohibition wave struck Norfolk and early callers finding only 'the cup that cheers' in the way of New Year greetings at some of the homes, forthwith put small chalk marks on the front steps so those coming after could read and give that particular house a wide berth."[125]

Many individuals, mainly women, began to speak out against the evils of alcohol and call for the prohibition of the beverage. To understand the connection to ice water, one must understand that the typical dinner service consisted of alcoholic beverages as accompaniments to each course in a meal. Therefore, by offering ice water at the dinner table instead of alcoholic beverages, the hostess could have been exerting her influence as a proponent of the temperance movement.[126] While this theory deserves to be presented, it does not necessarily apply to the

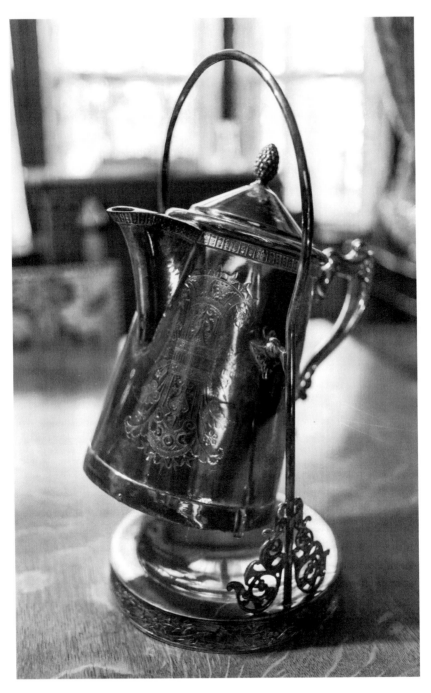

The tilting water pitcher, Hunter House Victorian Museum, Norfolk. *Courtesy of Cathy Smith Photography.*

Hunter family. There are no indications to suggest the Hunters were active in this movement, but this theory may explain why ice water became so popular in general in society throughout the nineteenth and early twentieth centuries in America.

The Kitchen, Laundry and Lavatory Facilities

The dining room features a door to the area of the Hunter home where the kitchen, laundry area, water closet and access to the basement are located. These areas are not open for public touring because they have been updated and are currently used by the museum staff for special events. Typical Victorian kitchens, though, would have been decorated sparsely and would have appeared very utilitarian. Servants would have prepared meals in the kitchen and used the old stove, which is currently located in the home's basement. The basement itself runs the entire length of the home, which would have been advantageous when heating the stove. Laundry would also have been done within this closed-off area.

Laundry was an all-day process for Victorians. While many did have access to machines by the end of the nineteenth century, the machines themselves were not as advanced as those used with electricity during the twentieth century. Larger households often employed a servant or group of servants whose sole duty was to clean the laundry. Clothing was custom-made and very expensive, and many fabrics were susceptible to shrinking or unraveling in the machinery, so servants had to take special care when cleaning personal items for their employers. Laundering materials was not only time-consuming but also very burdensome. Those servants assigned to the task would have needed to first boil the table linens, clothing and other delicate pieces before intensely scrubbing the stains within the cloth. Keeping in mind that the Victorians did not have access to many of the cleaning supplies available today, it is undeniable they would have dreaded attempting to rid fabrics of stubborn stains and residues like red wine, which even scalding-hot water could not remove. It is fair to suggest the laundress had one of the toughest jobs in the nineteenth-century home.

Inglenook: On the Staircase?

While ascending the staircase, guests pass the infamous inglenook. The term itself contains the root word for fire, indicating why it is located next to the fireplace. What makes this feature at the Hunter House so unique is not that the home contains an inglenook, for each Victorian home of status would likely contain one, but that the inglenook in this home is located on the landing between the first and second flight of stairs. Inglenooks generally were located on the first floor either adjacent to or just past the entryway. Guests visiting prominent families would be ushered into their home by a house servant, present their calling cards and wait by the fireside for an audience with the lady or man of the house. Those visiting the Hunters would

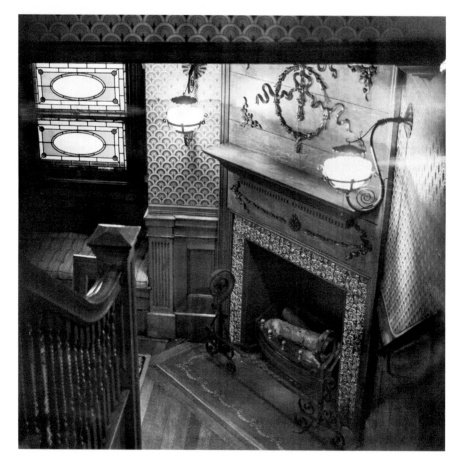

The infamous inglenook, Hunter House Victorian Museum, Norfolk. *Courtesy of Cathy Smith Photography.*

certainly be impressed by the cozy fireside window seat, with its stained-glass window and ornately decorated fireplace. Encaustic and glazed tiles adorn the hearth, and iron light fixtures are located on either side of the fireplace, flanking the hand-carved woodwork and appliques on the mantel. It is still a subject of debate, however, as to whether guests of the Hunter family would have actually waited for them in this particular area. Its placement causes a privacy issue, as the second-floor bedchambers can be viewed if seated in the inglenook. For this reason, it can neither be confirmed nor denied that the inglenook in this home was used for its intended purpose. General consensus is the inglenook on the landing simply may have been an artistic feature of the home meant to draw in visitors.

The inglenook was not just a waiting area for visitors, however. Often, the nook on the stairs served a social purpose. Sons and daughters could use the space for courting potential mates, although not with any promise of privacy. "Privacy" was reserved for the second and third floors of the home, where sleeping quarters were located. Courtships birthed in the inglenook were overseen by members of the family and staff from various vantage points throughout the house. Maids and family members could watch from above through the doorways of the various bedrooms or from below by peering around the corners of the parlor and library walls. Young love could not blossom without these chaperones.

The Second Floor: Privacy, Children and Sleeping Quarters

The importance of the Victorian bedroom is best characterized by Elan and Susan Zingman-Leith: "The bedroom was the scene of many of the major passages of life: birth, marriage, and death. Before people visited hospitals, the bedroom was their entrance and exit from the world."[127] This would have been the case for many Victorian families, including the Hunter family, all of whom died at home with the exception of James Hunter Jr. While none of the Hunter children was born in this home, they would have been born in their previous home in the days before there were birthing wings, let alone hospitals. The bedroom truly became the place where life was lived, in its purest form.

The first room museum visitors enter on the second floor, and arguably the best room upstairs, is the front bedchamber. This room was the secluded

area in which Eloise spent her last years in the home. It has a very feminine feel, and rays of sunshine gleam through the large bay windows. Tucked away within the alcove is a seating area, featuring a pastel green upholstered chair from the late 1800s and a Spanish copy of what Americans would liken to a copy of *Ladies' Home Journal.* Here, any one of the female family members could have rested on a spring morning, listening to the chirping of the birds and catching up on the musings of highly regarded female magazines of the day. At this point, it should be noted that the Hunter family home, while it did come with floor plans and other architectural sketches, did not have designations for the bedchambers. In other words, it is not known in which bedroom each family member resided. In fact, they probably switched bedrooms during their lifetimes. Aside from the previous comment about Eloise, what follows about the occupants of the other bedrooms are deductions.

It is very likely Mr. and Mrs. Hunter did not share the front bedchamber, as separation between couples was customary in many Victorian homes. The front bedchamber is connected via a walkthrough closet to the back bedchamber where it is believed Mr. Hunter resided. They could have shared closet space, which in itself was very innovative in the nineteenth century, while not sharing a bed. Mrs. Hunter would have resided in the front bedchamber throughout her life, only to be replaced by one or both of the girls throughout the subsequent years. While the bedchamber was in use, it acted as a beautiful hideaway for the mistress of the house.

To expand on the topic of closet space, it should be noted that homes that contained closets were not the norm in the nineteenth century. Most homes instead contained bureaus, which housed a few gowns or other articles of clothing. Closets became popular during the early twentieth century, as architectural practices morphed into something more contemporary. There are many arguments regarding the innovation and expanding popularity of closets. Again, the Zingman-Leiths provide the best explanation for the phenomenon:

> *The real explanation for the scarcity of closets is the abundance of servants. The lady of the house would leave a card on her vanity describing the evening's outfit, and her maid would retrieve the clothes from an upstairs room where they were packed in chests of drawers, armoires, and boxes. The maid would steam or iron the clothes and lay them out on the bed ready to be put on. There was no incentive for making clothes storage convenient as long as someone else fetched them.*[128]

A Home for Mr. Hunter

The Hunters did have such a room on the third floor, which they used to store not only their clothing and other fashionable accoutrements but their steamer trunks as well. They most certainly would have had a maid fetch their belongings when needed, although probably not at the frequency the aforementioned authors describe. While wealthy, the Hunter family was not so wealthy as to have servants treat them like the Vanderbilts or Carnegies of the Gilded Age.

The bedroom is filled with many other treasures, most of which take the form of furniture. A beautifully crafted bed created in the Renaissance style is the most noticeable piece in the room. Built in 1872 in Grand Rapids, its headboard stands seventy-two inches tall against the far wall. At the foot of the bed sits the family's rocking cradle, a gem brought over from their previous home on Boush Street in Norfolk with the hopes of future little ones. In the far corner, a bridal chest brings an oriental influence into the room. Various dance cards sit atop its shelves, each with the first and last dances blank. It was custom for engaged or married couples to dance the first and last dances of the evening, exclusive of singles. This certainly had its advantages. From the very beginning of the dance, a participant could immediately know which young ladies or gentlemen were available for courtship. On the other hand, it also singled out those individuals who were not succeeding in the marital department. Social dancing became a common mode of beginning a courtship during the eighteenth century and lasted through the twentieth century. Gentlemen would ask for a specific dance and would sign their names to those dances. It was deemed improper to dance with the same gentleman multiple times, so ladies had to be careful to spread their affections throughout the room of eligible gentlemen. After all, one never knew when an offer of marriage may be in the works, as the gentlemen of the family fancied themselves matchmakers, even if only in the financial sense. Harriet and Eloise must have been too precious to their family to marry off to just anyone, as any offers of marriage made to them obviously never resulted in the act itself. It is still amusing to imagine the girls twirling about in their hand-sewn evening gowns, even if those dances never resulted in marriage.

The last piece of note is the hair receiver located on the dressing bureau along the wall. The tiny object is easily missed by guests unaware of its purpose. The rounded ceramic jar acted as a place for women to collect their hair from their brushes and combs. Once enough hair had been collected for a particular project, these women would use their hair as the base for crafting different objects. Hair became a product used by the poor to sell

A collection of dainty items for the ladies in the front bedchamber, Hunter House Victorian Museum, Norfolk. *Courtesy of Cathy Smith Photography.*

for wigs and by the wealthy for jewelry and decorative objects.[129] Within the Hunter Home, the girls may have used their own hair to craft gifts and home décor objects. Unfortunately, none of these projects has survived, if they were ever completed. There is, however, a donation of hair jewelry in the back bedchamber of the home. This piece contains human hair weaved within the materials of a pocket watch fob. While this piece did not belong to the family specifically, it is an excellent example of the creative and sometimes morbid nature of the Victorians.

Morning Room and Washroom

Adjacent to the front bedroom is a morning room, a space dedicated to the duties of the lady of the house. Mrs. Hunter would have spent her morning hours in this room, taking care of correspondence and possibly spending time with the children. Maintaining correspondence with friends and family was one of the most important responsibilities of a Victorian woman, next to raising good Christian children, of course. The Victorian lady was the backbone on which society was built, as previously discussed with the process of calling. Yet women were often more involved in their communities outside the household than they are given credit. When not taking on volunteer roles

in the church, many women joined social circles to indulge in their interests. The Hunter girls, Harriet and Eloise, spent their time in various genealogical and philanthropic organizations throughout their lives. They were very proud of their family lineage and involved themselves in organizations that prized their family's historical importance. Scholar Bradley Brooks makes an interesting discovery that may have applied to the motivations of Harriet and Eloise to join these organizations. He states:

> *In reaction to* [increased immigration]*...the late nineteenth and twentieth centuries witnessed the founding of numerous prominent genealogical and preservation organizations, including the Association for the Preservation of Virginia Antiquities (1889), Colonial Dames of America (1890),* [and] *Daughters of the American Revolution (1890)...* [which] *encouraged Americans to rediscover and reassert their lineages, their hereditary links to ancestors and the past, rewarding connections to certain progenitors with memberships and badges.*[130]

Harriet and Eloise certainly took pride in their heritage and went through the tedious processes involved with determining one's family origins and tracing their ancestors. Organizations like the Daughters of the Confederacy and Daughters of the American Revolution were very selective in the women they incorporated into the organization. Each woman had to have a sponsor within the organization and be able to prove her lineage to the relative involved in either conflict. Proving lineage was the most difficult task, as each and every family member between the woman and the Patriot or Confederate had to be heavily documented. Furthermore, relatives by marriage were not considered direct descendants and eliminated the woman from the process. Only a true descendant, one who could prove a direct relation through the bloodline of the ancestor, could be admitted. Why go through all the trouble to join, then? Bradley Brooks's assertion seems like the most likely explanation. As the world around them changed into an industrial complex at the turn of the century, Harriet and Eloise witnessed the steady rise of immigrant workers and their families in the area. To combat the feeling of being overrun by "non-Americans," they may have decided to turn to preservation of what they considered a truly American culture.

When not playing the heroines of American culture, the women of the Hunter family would have spent their time educating themselves in various art forms, especially in the writing of letters and embroidery. In the corner of the morning room rests a quaint writing desk adorned with old letters, stamps

and other writing accessories. Women were the sole figures responsible for disseminating the family's personal business to others. If someone in the family was ill, the matriarch would pen a relative or two to inform them of the malady. If this sickness turned to a deathly illness, preparations may be made for visitations by those family members via letters. Should the sick person in fact expire from the illness, then preparations for visits would be solidified and all family and friends would be notified through the post of the passing and the arrangements for the funeral. Funerals, like weddings, were considered formal occasions, and specific protocols were to be followed. Taking the steps necessary to have those actions occur was the responsibility of the lady of the house.

On the mother's writing desk there is a small envelope lined with black trim containing a handwritten letter detailing the passing of a family member. The black lining on the envelope would have immediately indicated to Mrs. Hunter upon receipt that someone had passed away or that the sender was still in mourning. Like so many other niceties and social rules of the time, the process of informing someone of a death had rules attached; however, none of the rules prior to the death of an individual outweighed the strict structure of mourning that would follow. Queen Victoria popularized mourning customs when the love of her life, her husband, Albert, died relatively unexpectedly. Victoria was overcome with grief and refused to wear any color other than black for the remainder of her life. This extended to her staff as well, who were to remain in solemn colors while in her service. The color black came to indicate that a person was in mourning over the loss of someone. Interestingly, though, the length and degree of mourning a person should observe depended on the relation of the deceased to the mourner. In actuality, a person's worth to the mourner could be readily determined based on the degree and length of mourning. Someone would mourn longer for a husband than for a cousin, but a husband would mourn less for a wife than a wife for her husband. Social hierarchy was solidified by this mourning structure, which had so many different rules that the Victorians themselves probably never mastered them all.[131] The Hunter family would have observed mourning customs for their own family members and for dear friends throughout their lives, especially as they themselves began to pass away. By the mid-twentieth century, however, mourning customs had lost their appeal, and they were replaced by the more common expressions of grief seen today.

On a lighter note, women also engaged in fairly frivolous activities to keep them busy and render them "accomplished." Embroidery became the

primary source of entertainment for women, next to music and socializing. Throughout the morning room and into the bathroom, guests can view examples of the type of embroidery the Hunter women would have practiced. There are monogrammed hand towels with large *H*'s on them, dainty handkerchiefs with various designs and even a framed sampler on the wall. Samplers were used to teach young girls how to stitch letters, numbers and designs. This particular teaching tool belonged to Harriet Ayers, the maternal grandmother of the three Hunter children. Done in her tenth year, this piece of fabric is one of the oldest in the house. The girls spent time practicing their embroidery in both sewing circles and on the sewing machine itself. Their 1866 Standard sewing machine is still preserved in the morning room with various spindles of thread alongside it. One of the most interesting pieces crafted by one of the girls sits unfinished in the home: a crazy quilt. This quilt, dated 1897 and attributed to Harriet, would have been created to display how accomplished she was in the field of embroidery. Girls strived to show off their skillset by taking extra pieces of various fabrics and stitching them together using intricate patterns of stiches to create a quilt. While it made a beautiful handcrafted work of art for the family, it also had a pragmatic purpose. Fabric was an expensive commodity, and the extra pieces cut away from the outlines of dresses and skirts would not have been something families would want to throw out. Rather than appearing wasteful, an adjective that would not appeal to Victorian sensibilities, families expressed the virtue of thrift by using the extra fabric to create something simultaneously utilitarian and attractive.

The flow of the home leads guests from the morning room directly into a room that appears to be a bathroom, except there is no lavatory. This walk-through washroom contains a pedestal sink and a claw-foot tub, both original to the construction of the home. Above the tub there is a tower of built-in cabinets that seem oddly placed so close to the ceiling. William Wentworth wanted to make use of every available space in the three-story town home, and this cabinet is a prime example of that fact. If they were ever used, they most likely housed bath towels and soaps used for bathing. The tub itself is beautiful, measuring nearly six feet long and perfect for soaking. Unlike its pedestal sink counterpart, the tub is exposed rather than incased in wood, although it is believed there may have been such a framework when the home was built. On the sink sits an old tube of Colgate toothpaste found in the home during renovations in the 1980s. Next to it, an eyecup and grooming kit can be found. A small glass mirror sits in the windowsill next to a hot water bottle. The looking glass itself is just large enough to see

a person's countenance but nothing more. Moreover, it is not very clear. Vanity was not prized during the Victorian era, so the lack of quality mirrors is almost a foregone conclusion.

This washroom, while small, fulfills its purpose to allow the family to maintain a clean appearance. The lavatories were located elsewhere in the home, one that could only be used if a person went out the back door of the home and around to the outside behind the kitchen area and another on the second floor just outside the doctor's study. Unlike many Victorian homes, the Hunter House was built with indoor plumbing, a luxury few could afford. This fact only adds to the assertion that the Hunter family resided in a very forward-thinking home at the turn of the century, thanks to a very modern architect and an industrial father.

Doctor's Study

Following the washroom through to the next room, guests find themselves in the doctor's study. This room is currently interpreted as a home office for Dr. James Hunter Jr., although it could also have served as a bedroom at some point in the house's history. Dr. James Hunter Jr. was educated at the University of Virginia and Harvard and ultimately became a cardiologist and radiologist. He was one of the first doctors to use radiation as a treatment option for skin and other conditions and was well known throughout the Hampton Roads area. After studying under local doctor Southgate Leigh, he opened up his own practice in downtown Norfolk at the corner of Granby and Tazewell Streets. Dr. Hunter was widely known throughout the area and helped the local community for the majority of his life. In 1916, however, he experienced what may have been one of the most difficult times in his life.

Local citizen Benjamin Burroughs suffered from eczema on his legs and ankles. When this affliction became too much to bear, Burroughs opted to seek a professional opinion on treating the skin disease. Nothing is known on how he came to find Dr. Hunter and seek his guidance, but at some point between 1915 and 1916, Burroughs went to Dr. Hunter for treatment. Hearing of the positive reactions of patients to X-ray therapy, a very new field in medicine, Dr. Hunter decided to try it as a treatment option. Burroughs agreed to the treatment. Unfortunately, the X-ray therapy was not as effective as either man had hoped. Burroughs suffered from severe X-ray burns, which ultimately disabled him. In the end, Burroughs decided

to sue Dr. Hunter for malpractice and payment for damages. *Burroughs v. Hunter* went on for a few years, indicating the difficulty in determining the verdict in the case. The last judge ultimately declared that while he did not think the damage was intentional on Dr. Hunter's part, the verdict would be found in favor of Burroughs for the damages he suffered. This trial drained Dr. Hunter and brought an end to the height of his career.

While none of the family members left behind diaries or journals detailing their innermost thoughts and feelings, the last will and testament of Eloise Hunter may give some insight into the effect this trial had on Dr. Hunter. In her will, Eloise states she desires for the new Hunter Foundation to oversee

> *a home for elderly gentlemen, including but not limited to bankers, and members of the medical and legal profession, who may have seen better days, but are in need or destitute or aged or infirmed, this home shall be known as the James Wilson Hunter Home and is established as a memorial to my father James Wilson Hunter, and to my brother, Dr. James Wilson Hunter, Jr.*[132]

This will leads the reader to believe Eloise must have witnessed some type of decline during the life of one of these men to suggest such a home be created. While the trial is evidence of a misfortune for Dr. Hunter, there is no evidence of misfortune on the account of Mr. Hunter. Therefore, deduction suggests Eloise and her sister perceived the damage the trial had on their dear brother and wanted to do something to honor his memory. The specifications of the James Wilson Hunter Home's inhabitants provide further evidence of this assertion. Only doctors, lawyers or bankers who are down on their luck can reside in the home. Today, the James Wilson Hunter Home holds eight residents in a neighboring white building that predates the Hunter House Victorian Museum. Over time, Mr. Hunter purchased the homes neighboring his own, to include one to its left and two to its right. The current theory is Mr. Hunter hoped each of his children would eventually move out into the surrounding homes and start their own families. When this didn't happen, the homes continued to be part of the family until they were sold off. The white home to the museum's left, however, was still part of the Hunter family when Eloise made her will. She must have decided it would be the perfect place to house the gentlemen she mentions in her will. To ensure the home would be created, she penned it in her will and set the framework to immortalize her brother in stone.

Prior to the malpractice suit, Dr. Hunter enjoyed many years as a prominent local practitioner. The pieces that now reside in his home office

indicate a thriving practice and a passion for his career. There is a variety of Mission-style furniture dating from 1895 to 1910 in the room, including a gorgeous desk on the back wall. There are numerous tools on this desk, including a stethoscope and thermometer. Volumes of works on medical practices fill the shelves of an old bookcase, many of which Dr. Hunter may have saved from his time in college. There are also photographs of Dr. Hunter throughout the room, documenting his life as a student, war hero and young professional and accomplished doctor.

Of all the tools and gadgets in this room, one stands out like a sore thumb. A contraption of metal and wood seems to symbolically represent the coming of the industrial age as it looms in the darkness of the corner of the room. This contraption, though, is no ordinary machine. It is one of the earliest electrocardiographs made in America. Found in the attic during renovations to the home, the electrocardiograph must have resided in Dr. Hunter's local practice at some point in his career. After all, he certainly could not fit it in his leather doctor's bag when making house calls. This machine could read a person's vital signs, such as heart rate, and allow the cardiologist to determine any abnormalities. Dr. Hunter would have found this to be a valuable new tool in his practice.

Back Bedchamber

The last stop on the actual tour of the museum is the back bedchamber, located directly across from the entrance to the doctor's study. This room probably once belonged to Mr. Hunter, as it connects via a walk-through closet to the front bedchamber. This room has suffered water damage over the years, and the wallpaper has been replaced, but it still reflects the major differences between a lady's and man's bedroom during the Victorian era. In contrast to the light and airy feel of the front bedchamber, the back bedchamber feels darker, with deeper-colored wallpapers and draperies. There are fewer decorations than in the front bedchamber, and the furnishings are less feminine as well. The dark-colored wood bed and dresser are done in the Eastlake style, which was very popular among the upper classes. The furniture is marked as being crafted in Grand Rapids during the 1880s. The headboard in this room has much more masculine features than the one in the front bedchamber, including a scroll detail along the top of the headboard. The carvings

on the headboard precisely match the carvings on the dresser, where a variety of male accoutrements were kept.

There are a few pieces of interest on the dresser for guests to view. Off to the side, there is a man's sewing and manicure kit, often referred to as a housewife. This housewife appears to have been issued to Dr. Hunter during his time in the war, but it remained with him and was probably used by him after the war's end. The presence of this kit often begs the question of why a wealthy man would need something like it. The quick answer is they were wealthy, but not that wealthy. This is where the distinction between old money and the nouveau riche really comes into play. Mr. Hunter was a working man, someone who worked his way up the socioeconomic ladder and became wealthy in the process. As someone who worked for his earnings, he naturally had a different disposition toward doing things for himself than his hereditary wealth counterparts. He may not have viewed it as an inconvenience or an impropriety to sew a loose button or trim his nails on his own. Those from an old money background would think otherwise. This is the first, and primary, reason. Secondly, having someone around to constantly cater to his every whim would have been an unnecessary expenditure. His wife and children certainly had some type of maid to help them with their clothing and everyday activities, but he did not need a gentleman to get him dressed in the morning before work or shine his shoes. The Hunters employed servants in the house to do what was necessary, not what was convenient. Anyone who had to work for their money knew it could be spent just as easily as it was earned, and Mr. Hunter would have certainly been smart and thrifty enough to understand the difference between a status symbol and a necessity. As a result, visitors can now view his "housewife" on the dresser.

The most interesting and grotesque item in this room is a piece of hair jewelry that was donated to the museum. While this specific piece of hair jewelry did not belong to the family, that does not indicate they never made anything out of human hair or gave such items as gifts. However, by the later nineteenth century, hair jewelry was falling out of favor, often being categorized as hideous or dismal.[133] Hair jewelry had much more prominence during the early Victorian or Romantic period between 1837 and 1860.[134] By the time the Civil War was underway, so many men were dying that creating hair jewelry became less of a fun craft and more of a memorial duty. Hair jewelry became less ostentatious and much more subtle between 1860 and 1865, as hair was downgraded to the underneath of jewelry pieces, removed from the wandering eye.[135] This piece is a braided watch fob, holding a pocket watch once worn by a

wealthy gentleman. The hair could have come from a variety of people, but the most likely culprits would be the man's wife or children. Hair jewelry, while most readily associated with remnants of the deceased, was also used as a sign of devotion when given as a gift. Perhaps this piece was given to a father by his child, who worked diligently to design the watch fob all by herself. Or perhaps it was crafted by his lovely wife, who wanted to show her devotion to him by giving a literal piece of her to him to keep with him at all times. Either way, if the object was crafted by a wife or daughter, the crafter was in for quite a tedious construction process. The Victorian lady would have to utilize knives, tweezers, gum and even occasionally a curling iron to get the desired look for the hair to be woven into the jewelry piece.[136] Once crafted, though, the personal nature of the item made it an excellent gift for a dear family member.

Aside from the two aforementioned items, the back bedchamber is relatively plain compared to the feminine aesthetic of the front bedchamber. Victorian men did not have the same taste for ornamentation as women did, and this is reflected even within their interiors. The Hunter family is no exception to this fact.

Nursery

Leaving the back bedchamber and journeying down the hallway leads guests first to a door, which, once they pass through, leads to another door to a large back room. This room now serves as the museum gift shop but once would have been used by the girls when they initially moved into the home. Labeled "nursery" on the architectural plans, this room never saw that purpose fulfilled. Harriet and Eloise may have shared this room as young ladies until space was available on the second floor for them to move elsewhere. The bedrooms on the third floor were not for the family but for guests of the house.

This room is very large and bright, with many windows and even closet space. It would have made the perfect hideaway for the girls, who must have been very fond of each other, as stories of them in their old age describe them as nearly inseparable. This room was the perfect place to foster sisterly affection.

Only the very rich had children who were "seen and not heard." Children were almost always treated as tiny adults, taught to exhibit only the highest

levels of decorum by their nannies in their nurseries. Mothers rarely spent time with their children, save special occasions. In fact, wealthy women often only saw their children at teatime, dressed in their best clothes and presumably on their best behavior as well. The nanny and the nursery maid brought up the children, not the parents. Once born, children were almost immediately turned over to a maid who would oversee their care as they were crafted into respectable young men and women.

Mothers were not void of love for their children, however. In fact, many fretted over whom they should hire to take over their role as caregiver. In publications around the turn of the century, mothers were advised to hire young ladies of poor but good families to be nursery governesses. It was assumed these women would not gossip about unsuitable matters in front of the children, as they would need to remain in the household staff to make a living wage and would not have the need to sell family secrets to others in high society.

Of course, most middle- and lower-class women did not even need to concern themselves with a nanny or maid for their children. These women would occasionally hire a maid to aid in household duties but would take on the motherly tasks of teaching and taking care of the children. One of the other major duties of these mothers, both in name and in practice, was nursing the sick. They would do so by using the many medicines available then, most of which contained opium or other dangerous substances. During the Victorian period, it was not required for drug manufacturers to divulge a list of ingredients and dosages on the bottle of medications, so babies could easily be given a fatal amount. In an age when smallpox, measles, diphtheria, cholera and typhus were common, this meant that small children were lucky to survive to their fifth birthday. Mothers of the period were all too aware of this likelihood.

If children were lucky to survive their early years, they were subjected to an initiation process into society. First and foremost, fashion became an identifier of status and childhood development. Wealthier young girls were dressed in garments similar to their mothers but shorter. Their hair was allowed to remain long but must have been tied back. When they were considered to be grown into adulthood, most likely around the time of puberty, their hair was put up and their skirts were lengthened to touch the floor. Around the same time, approximately age thirteen, these girls began donning corsets to give themselves desirable figures. Fashion began to dictate their lives as they moved toward coming out in society and being eligible for marriage. They were taught the skills of music, drawing and sewing to make them more desirable as potential mates for males in the community. Boys,

on the other hand, were put into gowns or dresses until they reached the age of six or so, at which point they were permitted to wear pants. Upon the appropriate age, wealthy boys went to school with the intention of eventually learning a specialized skill or trade.

Among the many things the rich and poor experienced differently, danger of disease was not one of them. It might be thought that children from wealthy families would at least be helped by being well fed, but in fact, they were malnourished. Malnourishment was often a sign of status, as exhibited by the various garments used to conceal a woman's true figure, among other social norms. The Bronte sisters, for example, were often hungry because they were told girls were expected to willingly subdue their appetites. Many diaries of the time reveal that children were expected to eat very simple food, even if better fare was available. Greed was considered to be a moral failure, one of the seven deadly sins no child should indulge in. For the poor, hunger was an everyday fact of life. Starches and broths became mainstays in their diets, as they were inexpensive, while meat was for the men of the house. The rich, though, dined on the best, often turning to the icebox to keep foods fresh.

Overall, everyday existence was difficult for both rich and poor children in Victorian times. Life was not guaranteed by any means, and by surviving into prepubescence, children solidified their future roles as pawns in the marrying game. Despite the negativity often associated with being a child during the Victorian period, the era is still remembered with admiration as one of possibility and adventure.

The Third Floor: Use and Layout

While the third floor is not open for public touring, it is still an interesting part of the home to explore as a behind-the-scenes guest. The third floor contains four rooms, much like the second floor, with the addition of an attic space. Little documentation exists on the use of the third floor by the Hunter family, but it is believed they housed a secondary library in one of the larger rooms, as many of their books still sit there today. The books in this room are either in such poor condition they are not fit for display downstairs or are very rare pieces that need to be housed separately. Despite the dilapidated condition of many of the books, the family kept them for future generations. There are probably approaching many hundred books in this room.

In addition, there would have been another room dedicated simply to storage space for items such as extra clothing, steamer trunks, home décor, bulky furniture pieces and excess linens. Anything that was not in style would have been housed in this room as well. Victorians were proponents of eclecticism, but like any modern woman would say, sometimes items passed from a mother or mother-in-law did not reflect the individual style of the recipient. These items had to be kept but not necessarily displayed, and so many may have ended up in this catchall storage room.

The other two rooms would have served as guest bedrooms. The Hunter family did not have an abundance of family members who came to visit, but it was always appropriate to offer their house as a place for lodging to relatives and friends passing through the area or coming to visit. In accordance with social custom, these rooms would have been kept up for such occasions.

The third floor, unlike most upper floors, did not hold servants. The Hunters had a servant staff who were considered day servants rather than live-in servants. The next chapter will focus more on this topic.

Chapter 4

HIRED HANDS

Life of the Day Servant

*T*he Hunter family, like most Victorian families, lived in a world where it was considered the wealthy class's duty to provide work for members of the lower class as servants. For the majority of Victorian houses, this meant housing, feeding, clothing and training a large workforce to ensure that every day ran smoothly for the family and their guests. The Hunters were in a minority group, however, which did not have to house, feed or clothe their workforce; rather, they paid them for a good day's work and their servants returned home to their families at the end of the workday. In the early hours of the morning, the same servants would arrive to tend to the family for the full day. These types of servants, known as day servants, were popular among upper-middle-class families living in cosmopolitan areas.

Unfortunately, few facts are known about who composed the workforce at the Hunter House. Based on the size and location of the home, it is safe to suggest the family had between four and six servants to tend to them. A cook, of course, was needed without question. Any family who had to cook their own food was not of any notable financial circumstance. To support the cook, there may have been an assistant of some sort who also probably did the laundry for the family. There would probably have been one male servant who acted as a man-of-all-work, tending to the gardens, the carriage and some of the duties typically assigned to a butler. Aside from this one male figure, the rest of the staff almost certainly would have been female. The girls and Mrs. Hunter would have required at least one lady's maid to aid them in dressing, grooming and other feminine duties. There must have also been a parlor maid

or a maid-of-all-work to assist in cleaning the more public rooms and answering the door for calling hours. In total, these servants would have made the house run efficiently despite their small numbers.

Although this is also somewhat of an assumption, it is more than likely that the servant workforce at the home stemmed from the African American community. Following the Civil War and Reconstruction, it was nearly impossible for this community of ex-slaves to find work. The typical mindset was: why should I, as an employer, now pay a workforce for the same work I did not have to pay them to do before the war? This attitude permeated the South, including Virginia, and did not let up for some time. Those families who did employ the freed slaves did so at the risk of facing much scrutiny. By the 1890s, this attitude had begun to recede slightly, and African Americans were accepted back into the workforce, but only in servant positions. Many worked on farms in the rural communities and in domestic service in the cities.[137] In cosmopolitan Norfolk, where there was a substantial community of freed slaves, the domestic workforce would have surged with eligible African American domestic workers. It is not at all improbable that the Hunters would have taken on many individuals from this community as part of their servant staff.

It is important at this point to note that many African Americans did not want to live in the same home as their employer and often sought out these types of day servant positions where they could "live out." It is not difficult to imagine why this would be the case. It would make little sense for a freed slave, who once was forced to live with his or her master in deplorable circumstances and separated from family members, would want to once again reside in a white person's home without the opportunity to have a life away from that work with a family. In actuality, "living in" was too reminiscent of slavery, and the freed community knew better than to give their once masters that type of power again. As a result, the number of live-in servants rapidly declined, and more domestics chose to find employment that allowed them to have lives apart from their work.

These servants played a crucial role not only in the management of the house they worked for but also in determining the social status of their employers. Oftentimes, if a family hired impudent workers, it reflected very negatively on them and the people who associated with them. As a result, families had to be extremely careful in who they hired and which servants they chose to trust as confidants. This was especially important during the lady of the house's calling period. Servants were the first face the caller would see. The serving woman opening the door was

responsible for delivering the calling card to the lady of the house. Within this role, this parlor maid or maid-of-all-work, depending on the size of the home, actually could exercise a degree of power. She could determine the importance of the visitor and the effect the visit would have on her employer. The lady of the house was often very aware of this fact and worked with her maid to ensure the guests invited into the home were of value to her status. Essentially, this maid could help create the social status of the household by determining who was an undesirable and who was an advantageous acquaintance. Over time, the maid could become one of the best assets to the lady of the house and her reputation.[138]

On the other side of this coin, servants offered an avenue within the household where the lady of the house could be the ultimate authority figure. Women were in charge of managing the servant staff, not men, and many viewed this managerial position as an opportunity to break away from the confines of female gentility. As part of her supervisory duties, the lady of the house could hire and fire servants at her leisure and punish and reward them as she saw fit. She could also instruct them on the proper way to carry out their chores, which must have been very tiresome for the poor servants, and even show them how to do those chores herself.[139] This hands-on approach was not for every lady, but a few did take advantage of the autonomy that overseeing servants offered them.

To make matters worse for the live-out domestic servant, studies have shown these men and women actually lived harder lives than their live-in counterparts. They lived their lives effectively on call, as their employers could need them at any time during the early morning or late night, especially if there was a special social engagement.[140] While many servants worked a typical workday from dawn to dusk, some employers required being on call as a caveat to continued employment. This led to a life of long hours and decreased personal time, whether alone or with family.[141] In actuality, being a day servant may not have provided as much independence as the domestic service community initially hoped.

AN ELEGANT ETERNITY

Elmwood Cemetery

ollowing their deaths, each member of the Hunter family was laid out in the front parlor, as was custom, for a wake, followed by a funeral. All members of the family are buried locally in a Victorian park cemetery called Elmwood. Recently added to the National Register of Historic Places, Elmwood Cemetery was built in 1853 and stands as a beautiful example of the Victorian worldview on death. For the Victorians, death was simply another part of life. It was a rite of passage that every person must undergo in order to be at peace and reunited with the Lord. As a result, their cemeteries are not the unkempt, unorganized lots of the eighteenth century but family destinations. Victorian families often spent entire days in the cemetery, cleaning off the headstones and footstones of deceased family members and stopping to have a picnic lunch under the oak trees.

There is something genuinely romantic about Elmwood Cemetery. All around, death is portrayed as a gentle sleep. Small bed-like markers made of headstones and footstones mark the numerous graves of small children who died young but are now resting peacefully and eternally. Carvings in the stones designate symbols of slumber, beauty and guardianship. Throughout the cemetery, passersby can notice a variety of symbols, all of which have a secret significance. Every flower, every angel, every icon has an alternative meaning.

In Elmwood, many symbols are prevalent among the Victorian grave sites. Lilies, for example, represent purity, while ivy symbolizes fidelity and eternity. Symbols for mourning include ferns, draperies on urns and

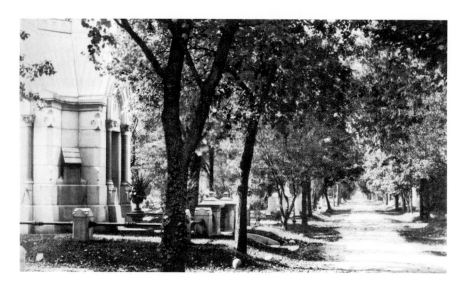

A mausoleum in Elmwood Cemetery, Norfolk's own Victorian park cemetery. *Courtesy of Sargeant Memorial Collection, Norfolk Public Library.*

weeping willows. Tones of happiness are reflected in images of rebirth and resurrection portrayed in the forms of flying angels, seashells, butterflies and flying doves. Of course, there are also numerous examples of Christian iconography in the cemetery. Bibles, the Ark of the Covenant, rosaries, crosses and crowns on crosses can all be found in Elmwood.

Some of the more interesting figures in the cemetery are mourning figures and angels. Like the other symbols, each of these images contains a message to the observer. Mourning figures can be seen standing alone, in bas-relief, clutching larger life-sized crosses or even prostrate on stormy, rocky shores. All these representations are meant to conjure feelings of grief and loss. Angels, on the other hand, often have much more positive connotations. Guiding angels are portrayed with up-stretched arms, pointing a finger for the deceased upward toward the heavenly afterlife. Guardian angels are often found with arms protectively wrapped around a tombstone, almost always for a small child. Recording angels are some of the most prevalent, depicted writing the name of the deceased in the book of life. This obviously represents the hope that the impact of the person will be remembered and that he or she made a mark on the world.

Other symbols include those that are more exotic in nature or turned to the past for inspiration. Broken columns are everywhere in the cemetery, a symbol taken from classical Greek and Roman culture to represent a life

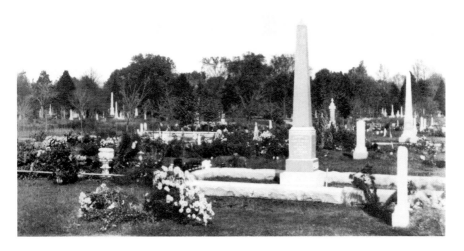

A scene in Elmwood Cemetery. *Courtesy of Sargeant Memorial Collection, Norfolk Public Library.*

cut short. Other odes to ominous deaths include handshakes, upside-down torches, hourglasses and broken wreaths. The obelisk, which is rooted in Egyptian ideas of the pyramids that symbolized eternity and the afterlife, can also be found in Elmwood. These were commissioned by wealthier families, more often than not, as representations of their societal dominance. Of course, mausoleums are also within this park cemetery, reserved for the wealthiest of the wealthy.[112]

The Hunters, however, have much less ostentatious graves in a front wing of the cemetery. Their five headstones are tastefully decorated, as many of the others in the cemetery are. What is interesting about their graves, however, is how the daughters are portrayed. There is a marker between the two that indicates they were members of the Daughters of the American Revolution. Even in death, they were concerned with writing their place in history as descendants of a founding family.

Markers like those in the Hunter family plot were not uncommon. Victorians were proud of their associations with various organizations and often chose to have those associations immortalized at their gravesides. There are symbols in Elmwood relating to various other organizations than the Daughters of the American Revolution or Daughters of the Confederacy. A blind justice with scales could often indicate the grave of a lawyer, while Bibles could indicate the grave of a minister. Three chain links symbolized the Independent Order of Odd Fellows, another fraternal organization like the Masons. There are symbols for the

Masons, Elks, Eagles, Owls, Pythians, Red Men, Moose and Woodmen of the World, among others.

Cemeteries were not created for the dead but for the living. Victorians understood the importance of ensuring their legacies could be understood and appreciated by visitors and included these types of symbols to leave their ancestors clues to the importance of their lives. The Hunter family, like many other Victorian families, indulged in these types of markers to indicate their achievements while on this earth. Now, they are forever immortalized in this historical park cemetery.

EPILOGUE

Remnants of the luxuries Norfolk's elite experienced during the Gilded Age still exist today. Many of the major public buildings continue to stand, although not all are still used for their original purposes. The first free public library in Norfolk still exists as a vacant building that has been for sale on Freemason Street for some time. Many of the old hotels have been turned into apartment buildings, as have many of the old shops downtown. Most of the shops mentioned in this book do not exist any longer, neither in concept nor building. Those that do have been repurposed for trendy shops on Granby Street, the retail destination downtown. Following Granby toward the interstate connection, tourists and locals alike cannot miss Norfolk's MacArthur Center, a shopping center named after General Douglas MacArthur. Down the way, Norfolk Stationery still thrives, though it has since expanded its inventory to include printer ink and copy paper, rather than simply pen and ink.

The Virginia Club continues to be a prestigious social organization for men downtown. Membership remains by invitation only, although its website suggests it is looking for more members to diversify its membership and make representation in its organization a more accurate reflection of the populace. The club continues to do great things to strengthen the economic and professional sectors of downtown Norfolk. Other professional business and fraternal organizations, such as the Elks, continue to exist today. Women have since worked their way into the public sector of Norfolk, working in some of downtown's banks and law offices. Some of the early bank buildings are

also still standing, many on aptly named Bank Street. From this perspective, not much has changed for the banking and professional industries since the turn of the century.

Of the personal residences of Norfolk's prominent historical families, some have been saved from demolition, while others have not been as fortunate. Many have since been sold off to new owners or passed down to newer generations in the family lineage. Many of the descendants of the families of old Norfolk still reside in the city today. Others have left their legacies by way of charitable donations, whether public or private. The Roper Performing Arts Center on Granby Street is run by Tidewater Community College but was originally named for Jeanne and George Roper. The Taylor-Whittle Home is used as the headquarters for the Norfolk Historical Society. Of the private homes available for tour, the Moses Myers House and the Willoughby-Baylor House, both on East Freemason Street, and the Hunter House on West Freemason Street are all that remain. The Moses Myers House falls under the jurisdiction of the Chrysler Museum of Art, as does the Willoughby-Baylor House, and offers tours throughout the year, while the Hunter House is run by the Hunter Foundation and offers tours April through December. In addition, Norfolk also offers visitors a glimpse into the past through the Hermitage Museum and Gardens, the MacArthur Memorial and the Norfolk Police and Fire Museum. Each celebrates a different facet of Norfolk's history, yet all expose the public to the importance Norfolk has played in the development of not only Virginia but the nation as well.

Religious institutions continue to grace the streets of Norfolk. First Presbyterian Church remains prosperous within the community, as do Epworth United Methodist Church, St. Paul's Church and others. Christ Church and St. Luke's Church have since joined forces and congregations to make Christ and St. Luke's Church, located now on Olney Road in the Ghent neighborhood of Norfolk, just around the bend from the Chrysler Museum of Art and its new Glass Studio. Norfolk's artsy feel has grown at the same rate as the number of coffee shops in and around town, some mom and pop and some catering to an intellectual crowd. Granby Street and its cross streets have also witnessed the rise of dining establishments, from a gourmet grilled cheese bistro to a high-rolling piano bar. Since the end of the Gilded Age, Norfolk has witnessed tremendous growth, and its forecast looks promising.

If you are ever in the area, make sure to experience an opera at the Harrison Opera House, a show at the Little Theatre of Norfolk or a movie

EPILOGUE

in Ghent's Naro Theater. Grab a bite from one of the many locally owned restaurants and purchase souvenirs from the gift shop at a local museum. Whichever attractions you choose to partake in, take the time to reflect on the foundations of the city laid so many years ago when Norfolk experienced the glamour and beauty of the Gilded Age.

NOTES

Chapter 1

1. Andrew Carnegie, "Wealth," *North American Review* 148, no. 391 (June 1889): 653–65. Carnegie's article was later published in part one of the text titled *The Gospel of Wealth*.
2. Emma Blow Freeman Cook, "Histories, Recollections and Anecdotes of Old Norfolk," edited by Arthur H. Riddick (Norfolk, VA: Ye Olde Towne Press, Particular Printer, 1937), 29.
3. George Holbert Tucker, *Norfolk Highlights, 1584–1881* (Norfolk, VA: Norfolk Historical Society, 1972), 114.
4. Ibid., 115.
5. Virginia Club, *Virginia Club Centennial* (Norfolk: Virginia Club, 1973).
6. Virginia Club, *Constitution and By-Laws of the Virginia Club of Norfolk, VA* (Norfolk, VA: Chas. W. Wilson & Co. Printers, 1873), 12.
7. Ibid., 13.
8. Ibid., 16.
9. Ibid., 18.
10. Ibid.
11. Ibid., 19.
12. Ibid., 20.
13. Lillias Campbell Davidson, *Hints to Lady Travellers at Home and Abroad* (London: Iliffe & Son, 1889).

14. "The Official Hotel Red Book and Directory" (New York: Official Hotel Red Book and Directory Co., 1927).

15. Ibid., 655.

16. Ibid., 654.

17. Ibid., 653.

18. Frances Elliot, *Diary of an Idle Woman in Spain*, 2 vols. (Leipzig, Germany: B. Tauchnitz, 1884).

19. Ibid., 1:31.

20. Ibid., 1:19.

21. Frances Elliot, *Diary of an Idle Woman in Italy*, 2 vols. (Leipzig, Germany: B. Tauchnitz, 1872), 1:32.

22. Ibid., 1:20.

23. Ibid., 1:38.

24. Frances Elliot, *Diary of an Idle Woman in Constantinople*, 2 vols. (Leipzig, Germany: B. Tauchnitz, 1893).

25. Ibid., 1:21.

26. Ibid., 1:32.

27. Ibid., 1:46.

28. Sarah Searight, *Women Travellers in the Near East* (Oxford, UK: Oxbow Books, 2005).

29. Amanda E. Williams, "Compartmentalizing the Other: Nineteenth-Century Englishwomen, Travel, and English Identity," master's thesis, Old Dominion University, 2008, 12.

30. Ibid., 12.

31. Lady Duff Gordon, "Letters from Egypt," In *An Anthology of Women's Travel Writings*, edited by Shirley Foster and Sara Mills (New York: Palgrave, 2002), 60–63.

32. Ibid., 63.

33. Ibid.

34. Mary Shelley, "Rambles in Germany and Italy," in *An Anthology of Women's Travel Writings*, edited by Shirley Foster and Sara Mills (New York: Palgrave, 2002), 108–10.

35. Edith Wharton and Ogden Codman, *The Decoration of Houses* (New York: Charles Scribner's Sons, 1897), 22.

36. Marlene Tromp, "Spirited Sexuality: Sex, Marriage, and Victorian Spiritualism," *Victorian Literature and Culture* 31, no. 1 (2003): 67.

37. Jennifer Bann, "Ghostly Hands and Ghostly Agency: The Changing Figure of the Nineteenth-Century Specter," *Victorian Studies* 51, no. 4 (2009): 665.

38. Ibid., 677.

39. Peter Lamont, "Spiritualism and a Mid-Victorian Crisis of Evidence," *Historical Journal* 47, no. 4 (2004): 898.

40. Ibid., 908.

41. Ibid., 911.

42. Elana Gomel, "'Spirits in the Material World': Spiritualism and Identity in the 'Fin De Siècle,'" *Victorian Literature and Culture* 35, no. 1 (2007): 199–200.

43. Judy Oberhausen, "Sisters in Spirit: Alice Kipling Fleming, Evelyn Pickering de Morgan and 19th Century Spiritualism," *The British Art Journal* 9, no. 3 (2009): 38.

44. Tromp, "Spirited Sexuality," 68.

Chapter 2

45. Chamber of Commerce, "Facts and Figures about Norfolk, VA" (Norfolk, VA: 1890), 41.

46. Ibid., 35.

47. H.W. Burton, *The History of Norfolk, Virginia* (Norfolk: Norfolk Virginian Job Print, 1877), 3.

48. Ibid., 5.

49. Cook, "Histories, Recollections and Anecdotes of Old Norfolk," 30.

50. Ibid., 31.

51. Burton, *History of Norfolk*, 5.

52. Ibid., 10.

53. Ibid., 20.

54. Cook, "Histories, Recollections and Anecdotes of Old Norfolk," 31.

55. Here, the author must give credit to Matthew Whitlock, a friend and colleague with whom the author is currently researching the topic of the Union occupation of Norfolk through the eyes of Camilla Frances Loyall. The author is indebted to Mr. Whitlock for his efforts in this project, which have led to some of the following assertions concerning Camilla and her diary.

56. Alf Mapp Family Papers, Special Collections and University Archives, Patricia W. and J. Douglass Perry Library, Old Dominion University Libraries, Norfolk, VA 23529, Diary of Camilla Frances Loyall, 6.

57. Ibid., 7.

58. Ibid.

59. Ibid., 13.

60. Ibid., 10.

61. C.W. Tazewell, ed., *Vignettes from the Shadows: Glimpses of Norfolk's Past* (Virginia Beach, VA: W.S. Dawson Co., 1990), 84.

62. Chamber of Commerce, "Facts and Figures," 59.

63. Ibid., 47.

64. Rogers Dey Whichard, *The History of Lower Tidewater Virginia*, vol. 1 (New York: Lewis Historical Publishing Company, Inc., 1959), 475.

65. Tazewell, *Vignettes from the Shadows*, 84.

66. Robert W. Lamb, ed., *Our Twin Cities of the Nineteenth Century: Norfolk and Portsmouth, Their Past, Present, and Future* (Norfolk, VA: Barcroft: 1887–88), 78.

67. Harold P. Clark, Clarice Gayle, Lucile W. Pearce and Winifred Sackville-Stoner, *History of the Tazewell House: Tales from the Wishing Oak* (Virginia Beach, VA: W.S. Dawson Co., 1991), 14.

68. Tazewell, *Vignettes from the Shadows*, 84.

69. Peggy Haile McPhillips, *Pages from Norfolk's Past: Norfolk's First Public Library*, Norfolk, VA: Norfolk Public Libraries, n.d.

70. Tazewell, *Vignettes from the Shadows*, 31.

71. Ibid.

72. Ibid.

73. Ibid., 30.

74. Ibid., 31.

75. Whichard, *History of Lower Tidewater Virginia*, 473–74.

76. Ibid., 474–75.

77. Cook, "Histories, Recollections and Anecdotes of Old Norfolk," 22.

78. William H. Stewart, *History of Norfolk County, Virginia, and Representative Citizens* (Chicago: Biographical Publishing Company, 1902), 288.

79. Ibid.

80. Tazewell, *Vignettes from the Shadows*, 25.

81. Ibid., 31.

82. Cook, "Histories, Recollections and Anecdotes of Old Norfolk," 23.

83. Ibid., 28.

84. Ibid.

85. Ibid., 32.

86. Tucker, *Norfolk Highlights*, 121.

87. Chamber of Commerce, *Pictures in Maritime Dixie: Norfolk, Va., Port and City* (Norfolk, VA: George W. Engelhardt, 1893), 120.

88. Ibid.

89. Cook, "Histories, Recollections and Anecdotes of Old Norfolk," 19.

90. Tazewell, *Vignettes from the Shadows*, 35.

91. Ibid., 39.

92. Chamber of Commerce, *Pictures in Maritime Dixie*, 33.

93. Cook, "Histories, Recollections and Anecdotes of Old Norfolk," 29.

94. Ibid.

95. Whichard, *History of Lower Tidewater Virginia*, 465.

Chapter 3

96. Christine B. Lozner, "National Register of Historic Places Registration: Church of Saint Lawrence," New York State Office of Parks, Recreation and Historic Preservation (January 1997).

97. "National Register Information System," National Register of Historic Places, National Park Service (March 2009).

98. Cheri Y. Gay, *Victorian Style: Classic Homes of North America* (Philadelphia: Courage Books, 2002), 24.

99. Ibid.

100. Ibid.

101. Hunter Foundation, "Biographical Fact Sheet: James Wilson Hunter" and "Biographical Fact Sheet: Lizzie Ayer Barnes," Hunter House Victorian Museum, 2014.

102. Hunter Foundation, "Biographical Fact Sheet: James Wilson Hunter Jr.," Hunter House Victorian Museum, 2014.

103. Hunter Foundation, "Biographical Fact Sheet: Harriet Cornelia Hunter" and "Biographical Fact Sheet: Eloise Dexter Hunter," Hunter House Victorian Museum, 2014.

104. Ibid.

105. Hunter Foundation, "Biographical Fact Sheet: James Wilson Hunter Jr."

106. Hunter Foundation, "Biographical Fact Sheet: James Wilson Hunter" and "Biographical Fact Sheet: Lizzie Ayer Barnes."

107. Hunter Foundation, "Biographical Fact Sheet: James Wilson Hunter Jr."

108. Hunter Foundation, "Biographical Fact Sheet: Harriet Cornelia Hunter" and "Biographical Fact Sheet: Eloise Dexter Hunter."

109. Roger W. Moss and Gail Caskey Winkler, *Victorian Interior Decoration: American Interiors, 1830–1900* (New York: Henry Holt and Company, 1986), 142.

110. Judith Flanders, *Inside the Victorian Home: A Portrait of Domestic Life in Victorian England* (New York: W.W. Norton & Co., 2003), 318.

111. Ibid.

112. Elan and Susan Zingman-Leith, *The Secret Life of Victorian Houses* (Washington, D.C.: Elliott and Clark Publishing, 1993).

113. Ibid., 35.

114. Ibid., 121.

115. Oliver Davie, *Methods in the Art of Taxidermy* (Philadelphia: David McKay, 1900).

116. Ibid., II.

117. Zingman-Leith, *Secret Life of Victorian Houses*, 121.

118. Susan Williams, *Savory Suppers and Fashionable Feasts: Dining in Victorian America* (New York: Pantheon Books, 1985), 59.

119. Ibid., 55.

120. Zingman-Leith, *Secret Life of Victorian Houses*, 13.

121. Ibid.

122. Williams, *Savory Suppers and Fashionable Feasts*, 152.

123. Ibid., 78–79.

124. Ibid., 53.

125. Tazewell, *Vignettes from the Shadows*, 40.

126. Williams, *Savory Suppers and Fashionable Feasts*, 134.

127. Zingman-Leith, *Secret Life of Victorian Houses*, 93.

128. Ibid., 115.

129. Henry O. Mace, *Collector's Guide to Victoriana* (Radnor, PA: Wallace-Homestead Book Company, 1991), 136.

130. Bradley C. Brooks, "Clarity, Contrast, and Simplicity: Changes in American Interiors, 1880–1930," in *The Arts and the American Home, 1890–1930*, edited by Jessica H. Foy and Karal Ann Marling (Knoxville: University of Tennessee Press, 1994), 35.

131. Mourning is a topic heavily discussed in the field of Victorian history but not as heavily in this work. Please consult the variety of fantastic scholarly resources available for more information on this subject.

132. This excerpt is taken directly from the last will and testament of Eloise Dexter Hunter, Part A of the eighth section, dated November 5, 1958.

133. Margaret Flower, *Victorian Jewelry* (Mineola, NY: Dover Publications, 2002), 41.

134. Ibid., 21.

135. Ibid., 32.

136. Ibid., 21.

Chapter 4

137. Faye E. Dudden, *Serving Women: Household Service in Nineteenth-Century America* (Hanover, NH: Wesleyan University Press, 1983), 64.
138. Ibid., 115.
139. Ibid., 163.
140. Ibid., 179.
141. Ibid.

Chapter 5

142. Special thanks are needed here for Tim Bonney, whose life work has been to preserve Elmwood Cemetery and educate the public on its importance. The author received the majority of this information on symbols and their meanings from Mr. Bonney and is forever indebted to him for his kindness and approachability regarding the importance of Elmwood Cemetery.

Index

A

American Revolution 16
Armstrong, Reverend George D. 38

B

banking houses 43, 49
Burroughs v. Hunter 91

C

Carnegie, Andrew 14, 46
churches
 Christ Church 53, 58, 108
 Epworth United Methodist
 Church 56, 58, 108
 First Presbyterian 38, 108
 Freemason Street Baptist 56
 St. Luke 56, 64, 66
 St. Paul's 37, 108
Civil War 38
 Loyall, Camilla Frances 39, 40, 41
 Union occupation of Norfolk 38, 41
Cook, Emma Blow Freeman 37,
 55, 58

Craven, Lady Elizabeth 26
custom house 60

D

Daughters of the American
 Revolution 66, 72, 87, 105
Daughters of the Confederacy 16,
 66, 67, 72, 87, 105
Dunmore, Lord 37

E

Elliot, Frances 24, 25, 27
Elmwood Cemetery 47, 67, 103, 105

G

Gordon, Lady Duff 26, 27

H

Home, Daniel Douglass 29
hotels
 Atlantic Hotel 17, 20, 23
 Hotel Fairfax 20
 Monticello Hotel 20

Hunter, Eloise 64, 65, 66, 67, 72, 84, 85, 87, 91, 94
Hunter, Harriet 64, 65, 66, 67, 72, 85, 87, 89, 94
Hunter, James Wilson 42, 64, 66, 91
Hunter, James Wilson, Jr. 64, 66, 90, 91, 92
Hunter, Lizzie Ayer Barnes 64, 66

I

inglenook 82, 83

J

Jamestown 35, 72

L

laundering clothes 81
Leigh, Dr. Southgate 49, 66, 90
local businesses
 A.J. Whitehurst & Bro. Grocers 55
 Ames, Brownley & Hornthal, Inc., Dry Goods, Millinery and Ladies Garments 55
 Great Atlantic and Pacific Tea Company 55
 J.W. & Co. Dry Goods and Notions 42
 Mr. Tripple's candy shop 55
 Norfolk's Palatial Turkish Baths 55
 Norfolk Stationery 55
 Paul-Gale-Greenwood Company Jewelers 55

M

Morris, William 67, 68, 70
mourning
 cemetery iconography 103, 104
 customs 88
 hair jewelry 85, 93

N

Norfolk Boat Club 47

P

post office 60
prominent families
 Blow 44
 Chamberlaine 18, 47
 Dancy 44
 Dey 49
 Dobie 44
 Doyle 18
 Grandy 44, 49
 Hardy 18, 49
 Leigh. See Leigh, Dr. Southgate
 Myers 44
 Nash 49
 Page 44
 Pickett 46
 Pinckney 18
 Ramsay 49
 Roper 14, 44, 52
 Rowland 18, 51
 Selden 44
 Sharp 49
 Taylor 18, 49
 Todd 18
 Toy 49
 Tucker 17, 18
 Tunstall 44, 49, 51
 Walke 18, 44, 49
 Ward 18
 Weston 44
 Whitehead 18, 44
 Whittle 44
public library 14, 46, 52

Q

Queen Victoria 15, 88

INDEX

R

Reconstruction 14, 35, 41, 100

S

schools
 Leach-Wood Seminary 51
 Norfolk College for Young Ladies 51
 Norfolk Mission College 51
 Phillips and Wests' 65
Selden, Dr. William Boswell 47, 49
servitude
 "live out" servants 15, 31, 55, 78,
 81, 84, 85, 93, 97, 99, 100, 101
 slavery 42, 100
Shelley, Mary 26, 27
social customs
 afternoon tea 15, 53
 calling 15, 28, 68, 69, 100
 dance cards 85
 dinner parties 15
 lectures 53
spiritualism 28, 29
 Fox, Kate 29
 Fox, Margaret 29
 ghostwriting 28, 31, 33
 mediums 29, 30, 31, 32, 33
 séance 28, 33
 women 28, 30, 31, 33
streets
 Bank Street 58
 Botetourt Street 47
 Boush Street 58
 Brambleton Avenue 48
 Bute Street 18
 Charlotte Street 48, 55
 Church Street 53
 City Hall Avenue 55
 College Place 51
 Commerce Street 42, 61

Freemason Street 18, 43, 44, 48,
 51, 52, 53, 58, 64, 107, 108
 Granby Street 17, 51, 55, 90,
 107, 108
 Main Street 17, 48, 55, 60
 Plume Street 48
 Tazewell Street 48, 55, 90
 York Street 43, 48

T

taxidermy 76
temperance movement 79
Tunstall, Dr. Robert. *See* prominent
 families

V

Van Wyck Academy of Music 55
Victorian scrapbooks 74
Virginia Club 17, 18, 19, 107

W

Wentworth, William P. 43, 63, 64,
 76, 89
Wharton, Edith 28
women
 correspondence 24, 33, 55, 67, 86
 embroidery 87, 89
 nursery 94, 95
 traveling 19, 24

Y

yellow fever 13, 38

About the Author

Jaclyn Spainhour is a native of Hampton Roads, where she fell in love with Norfolk and its past. She currently holds both an MA and BA in history from Old Dominion University in Norfolk, where she now acts as a history instructor. Additionally, Jaclyn serves as a history instructor for Tidewater Community College and as the assistant director of the Hunter House Victorian Museum downtown. She currently resides in a historic apartment building in the Freemason District with her loving husband, David, and their cat, R.G.